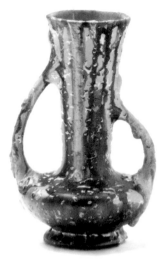

Darren Waterston's

Filthy Lucre

Whistler's Peacock Room Reimagined

James Robinson, Florence Tyler
and Darren Waterston

V&A Publishing

Published to accompany the exhibition *Filthy Lucre: Whistler's Peacock Room Reimagined* at the Victoria and Albert Museum, London, from 25 January to 3 May 2020.

This publication was supported by a generous donation from The Curtain Foundation.

First published by V&A Publishing, 2020
Victoria and Albert Museum
South Kensington
London SW7 2RL
vam.ac.uk/publishing

ISBN 9781 8385177 008 4

10 9 8 7 6 5 4 3 2 1
2024 2023 2022 2021 2020

The artwork *Darren Waterston: Filthy Lucre* was created by the artist in collaboration with MASS MoCA, North Adams, Massachusetts. Courtesy of DC Moore Gallery, New York.

Cover illustration and endpaper: Details from *Filthy Lucre*
Title page illustration: Vessel from *Filthy Lucre*

Designer: Will Webb
Copy-editor: Denny Hemming
Printed in the UK

V&A Publishing

Supporting the world's leading
museum of art and design,
the Victoria and Albert
Museum, London

Contents

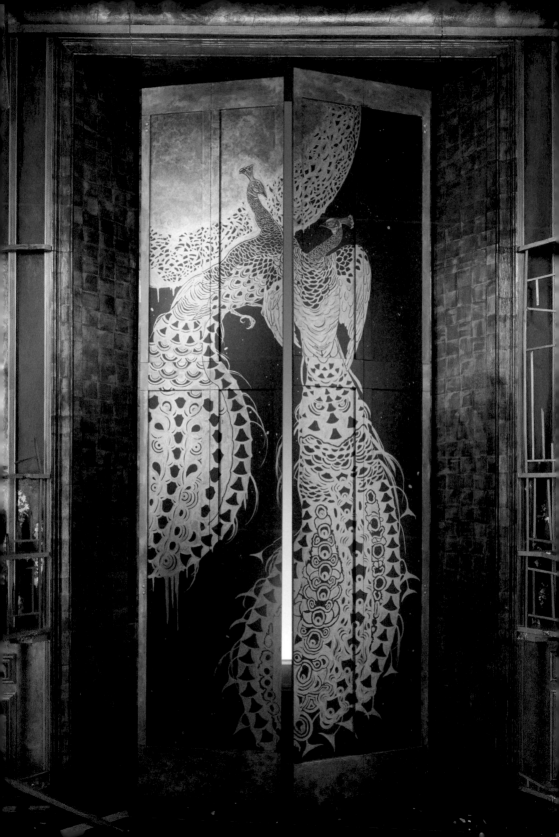

1
Filthy Lucre:
Artist's Statement

Darren Waterston

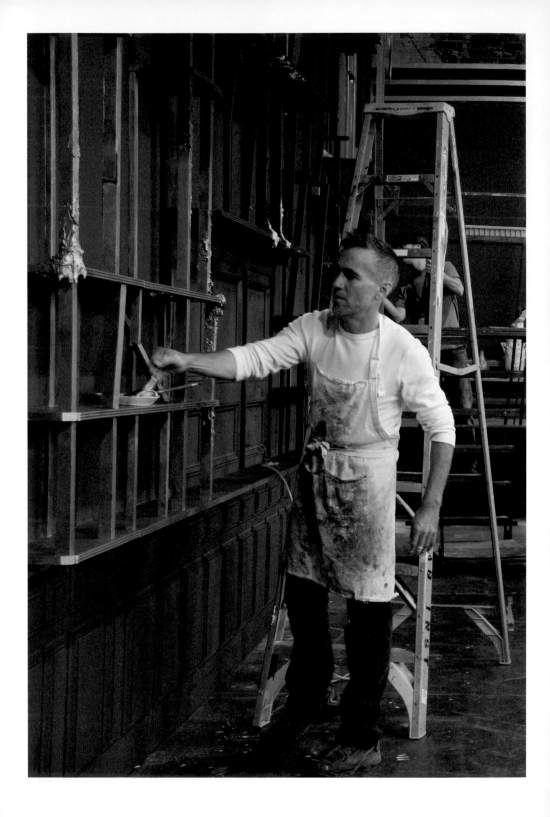

Page 4
Darren Waterston
Filthy Lucre, 2013–14 (detail)
Mixed media installation with
sound
Oil, acrylic and gold leaf on
wood, aluminium, fibreglass,
glass and ceramic,
370.8 x 929.6 x 604.5 cm

Left
**The artist working in MASS
MoCA Studio, 2014**

Overleaf
Concept wall for
Filthy Lucre

Pages 10–11
Darren Waterston
Serpent and Master, 2016
(detail)
Oil on wood panel,
121.9 x 121.9 cm

In deep mauves and Cerulean
blue, a colour invented in the
1860s around the time
Whistler painted the Peacock
Room, this work is both
seductive and menacing with
its serpentine forms and
decorative gold flowers.

Filthy Lucre is certainly a tribute to James Abbott McNeill Whistler's decorative masterpiece *Harmony in Blue and Gold: The Peacock Room* (1876–7). But more than that, I set out to create a work of art that would invite reflection on the subjective nature of beauty, excess and the grotesque. It has since provided a platform for later paintings, which, like ripples on a liquid surface, explore further the patterns, movements and palette of the installation.

My paintings and installations often create aesthetic tensions by striking a discordant note between beauty and disfiguration. In making *Filthy Lucre*, I brought my own painterly and sculptural sensibilities to bear on Whistler's fabled room, rendering it in a state of decadent demolition, as if it had rotted in on itself, heavy with its own tumultuous history and splendour.

I wanted to create a sumptuous, unsettling work of art that would also expose the tensions and emotional upheaval lurking beneath the dazzling surfaces of the *Peacock Room*. Its story is operatic but heartbreaking: that of art, egos and friendship lost. Whistler defaced – intentionally and in secret – the room's eighteenth-century leather wall panels and other valuable elements of the room's existing decor, thus altering earlier artistic accomplishments in order to make way for his own. At the same time that Whistler made this bold assertion of his own virtuosic grandiosity, he struggled with the ostentatious wealth and privilege of his patrons to whom he was so inextricably tied. This is the story of Art and Money for the millennium.

We are living in our own frenzied Gilded Age. The global art market supplies an unprecedented consumption of contemporary art as a consolidation of wealth, played out against the radical inequalities of our time. Artists are made inescapably aware that our creative efforts require the support of a now international class of patrons, whose aesthetic and political priorities can be markedly different from our own. *Filthy Lucre* seeks to illuminate the contradictions between how art is made, financed, collected and valued.

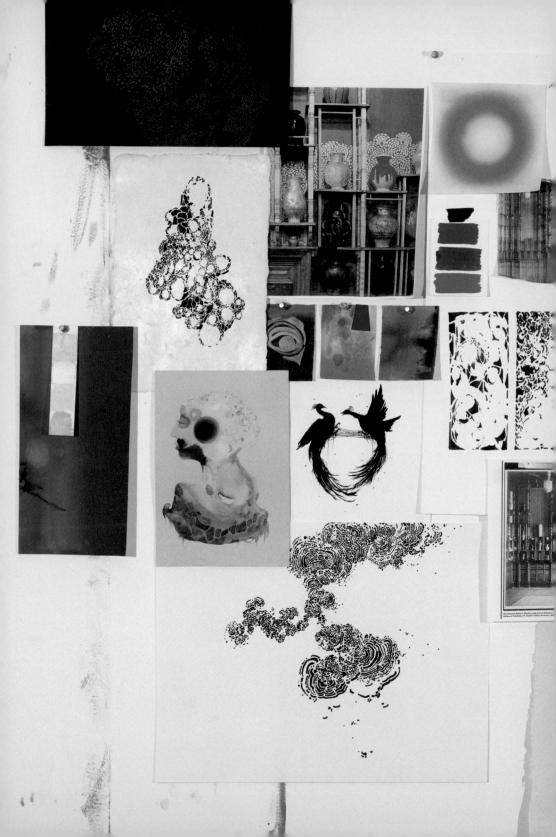

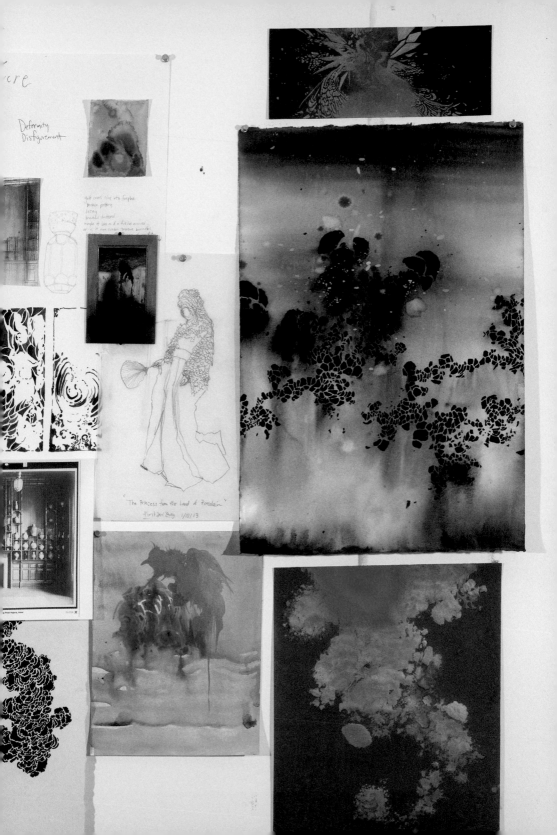

Deformity
Disfigurement

"The Princess from the Land of Porcelain"
First Day Bmy 1/12/13

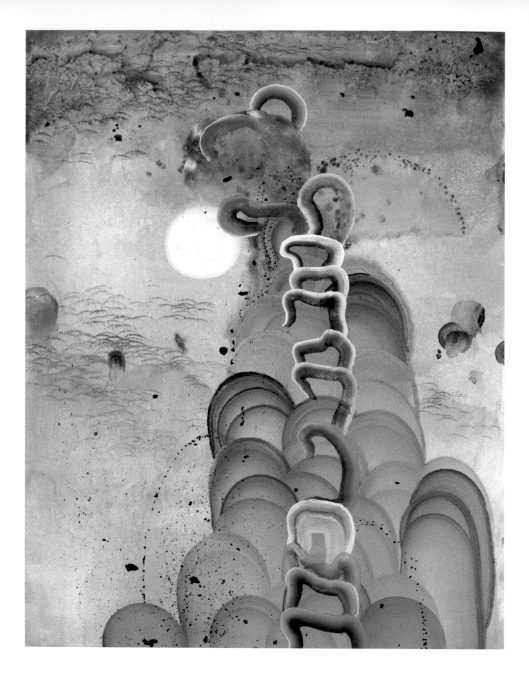

The *Pavo* works (above and opposite) are from a series named after the peacock genus and draw on the graphic motifs of *Filthy Lucre* as a point of departure. *Canto* (overleaf) takes many of its motifs and colours from the vessels and feathered wall-patterning.

Darren Waterston
Pavo no. 33, 2015
Mixed media on paper,
35.6 x 27.9 cm

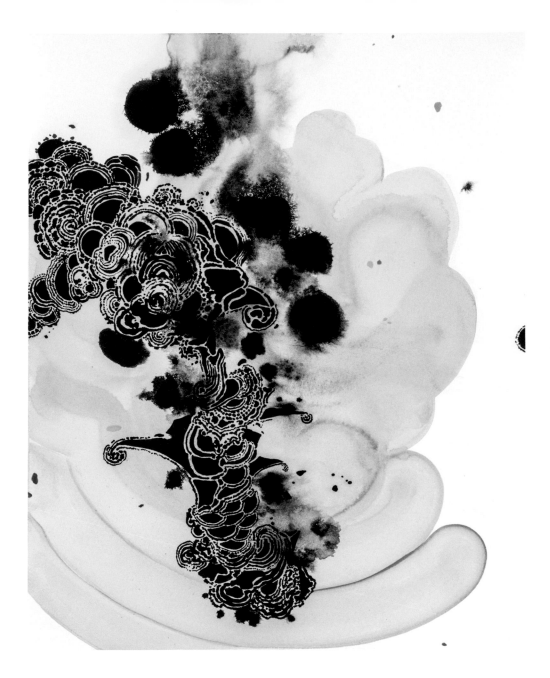

Above
Darren Waterston
Pavo no. 21, 2015
Mixed media on paper,
35.6 x 27.9 cm

Overleaf
Darren Waterston
Canto, 2019 (detail)
Oil on wood panel,
91.4 x 91.4 cm

Pages 16–27
Darren Waterston
Filthy Lucre, 2013–14 (details)

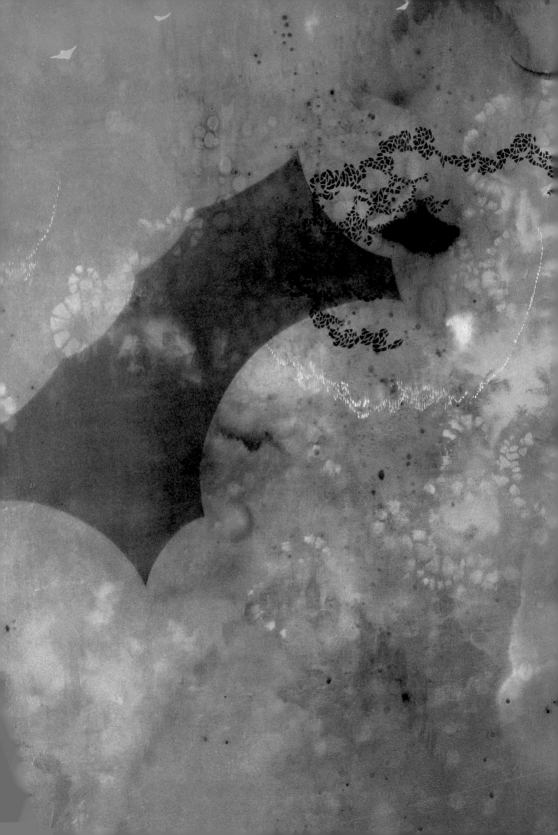

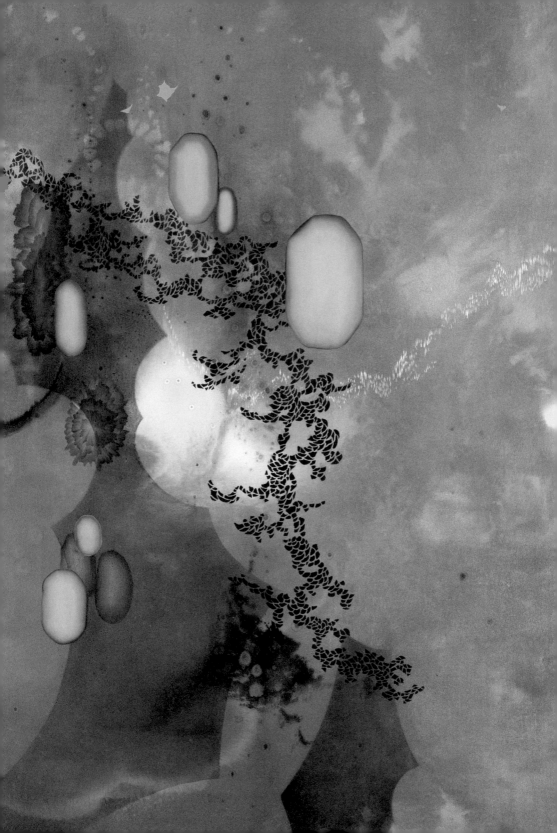

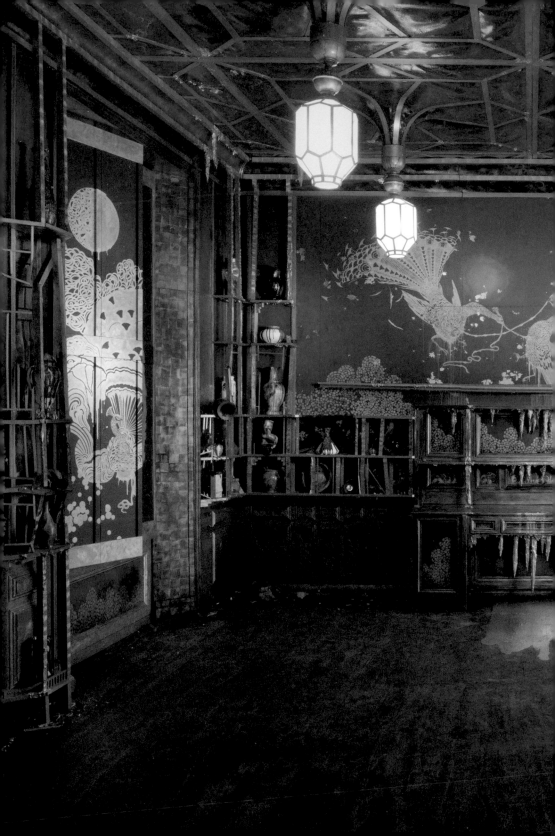

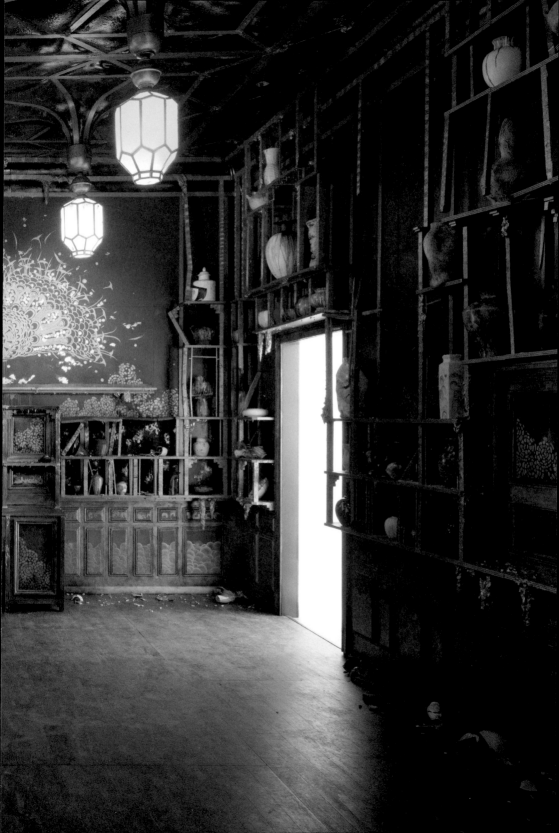

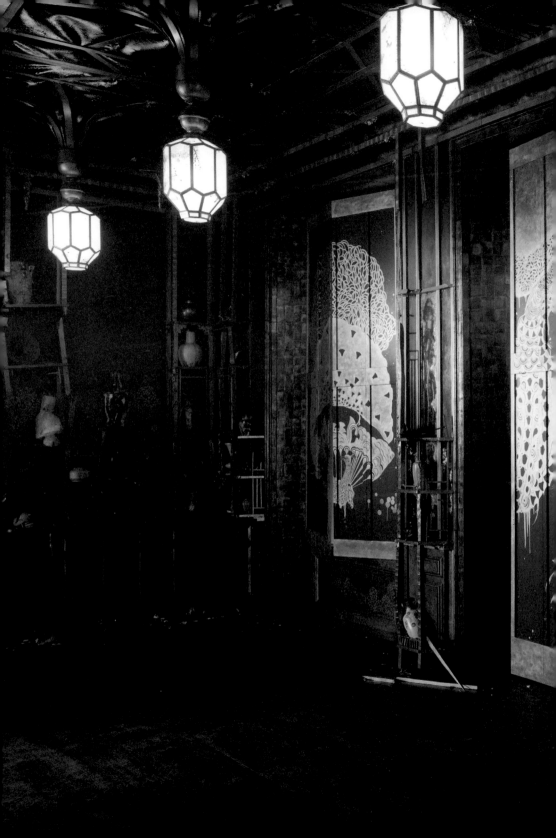

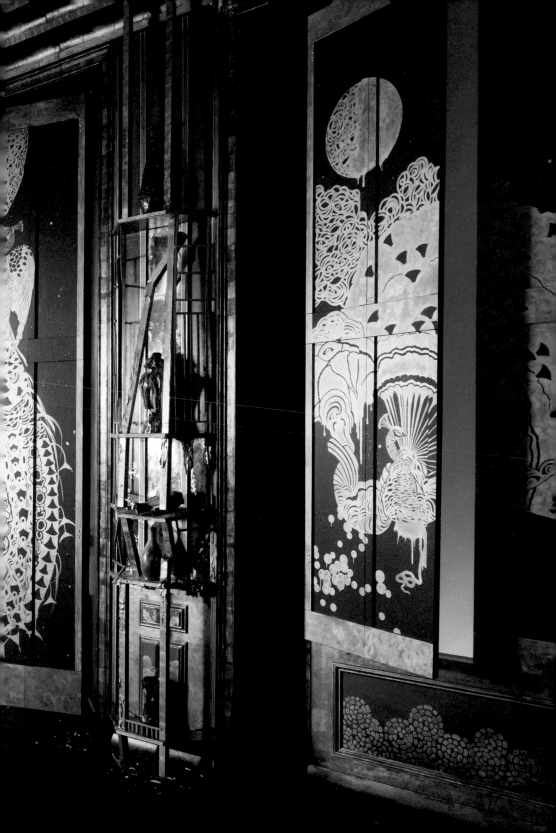

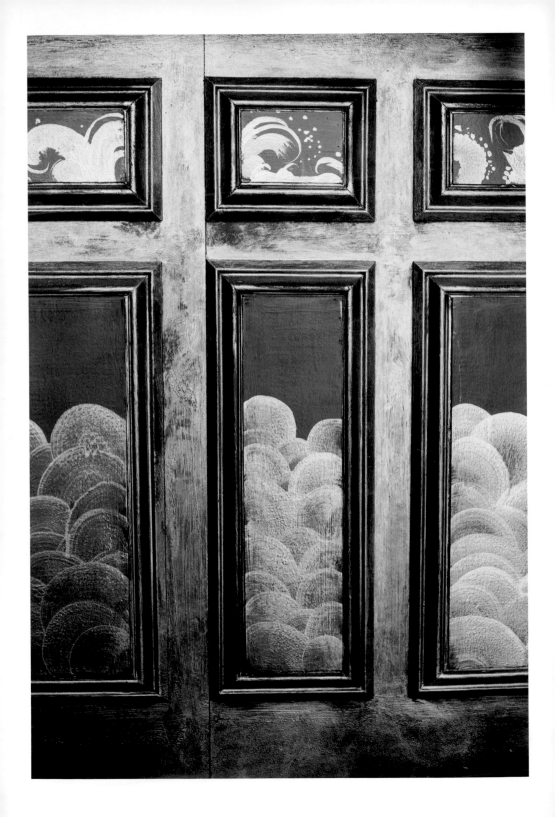

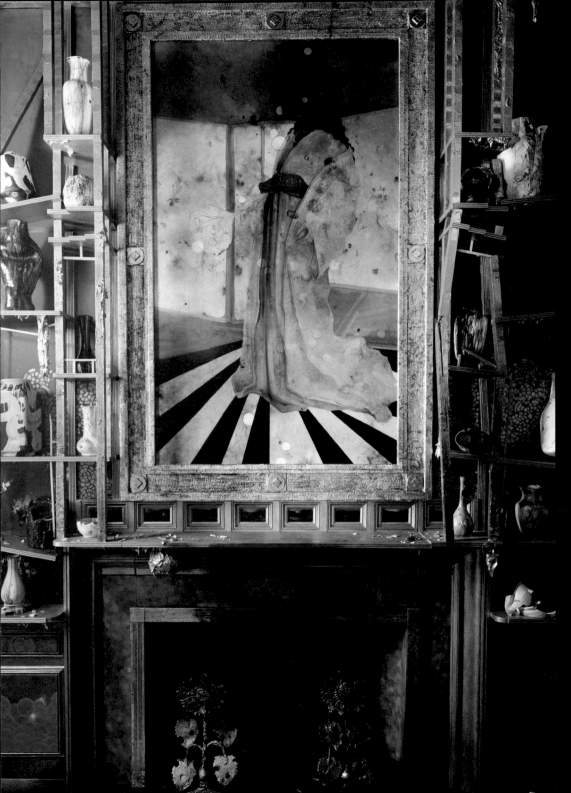

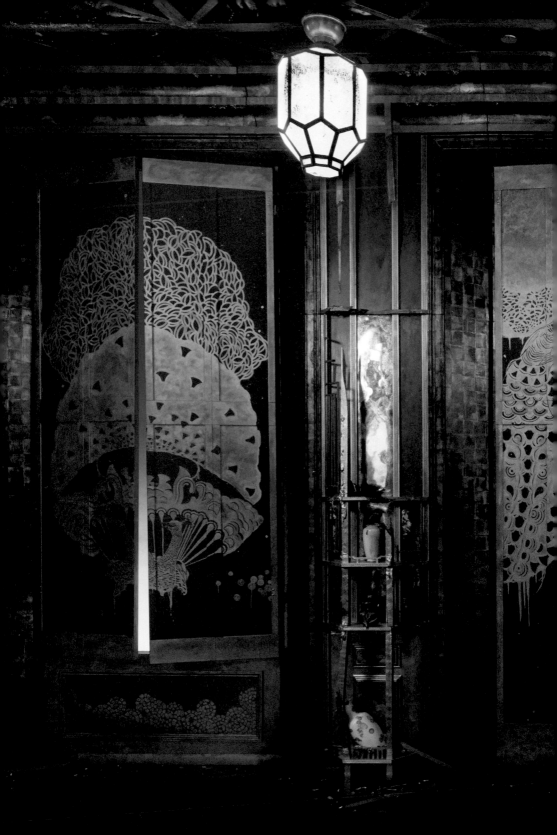

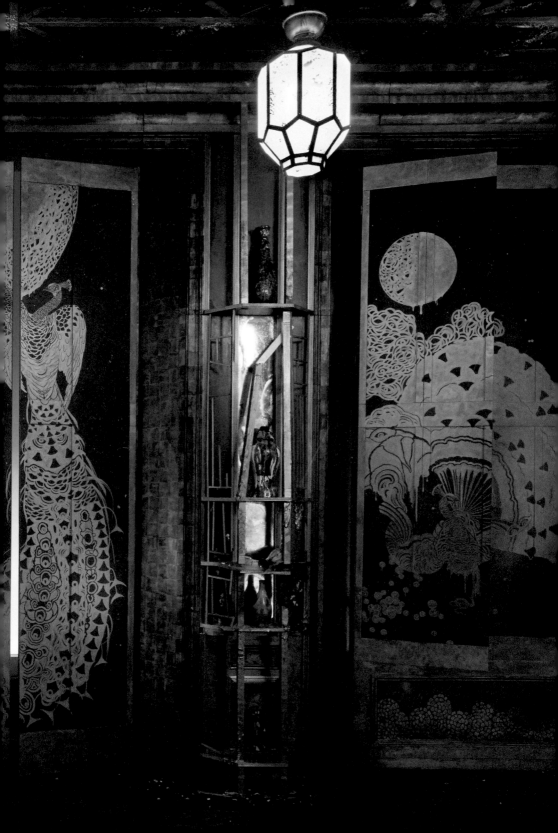

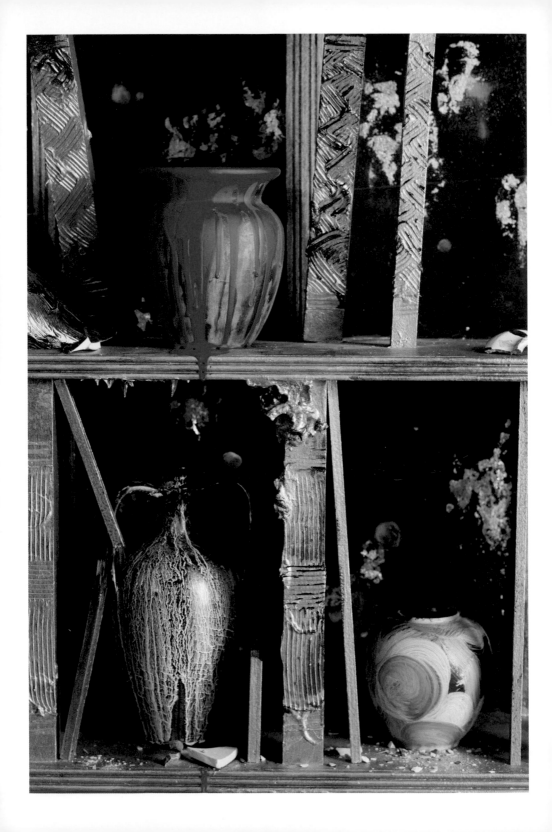

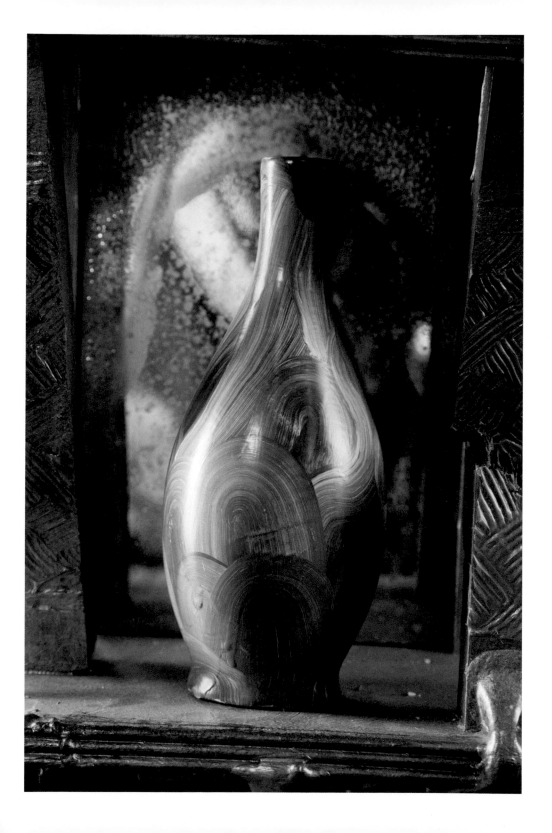

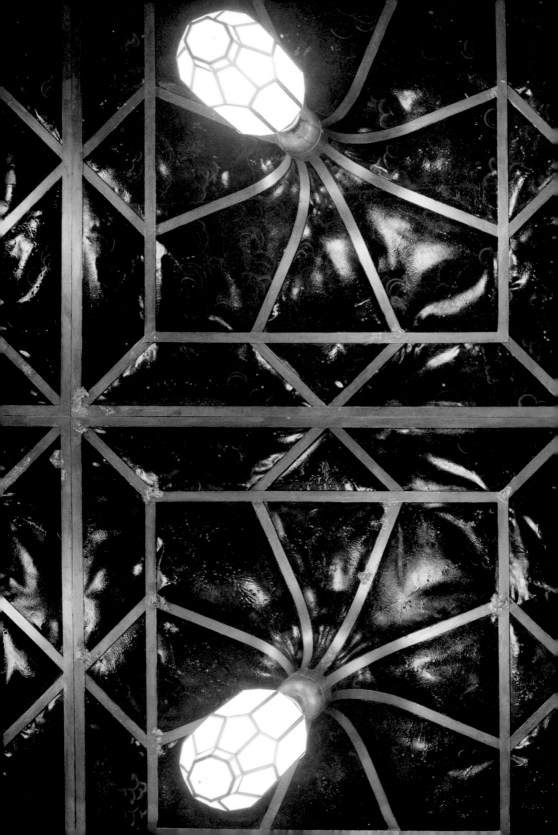

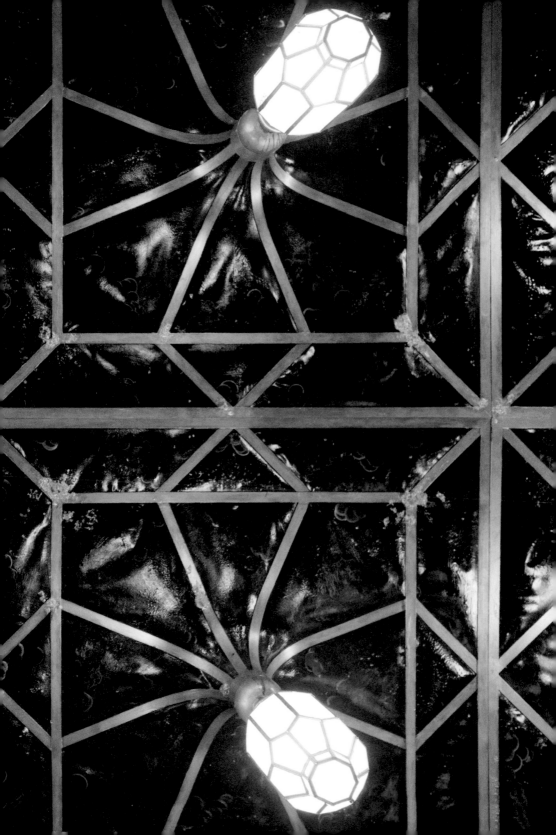

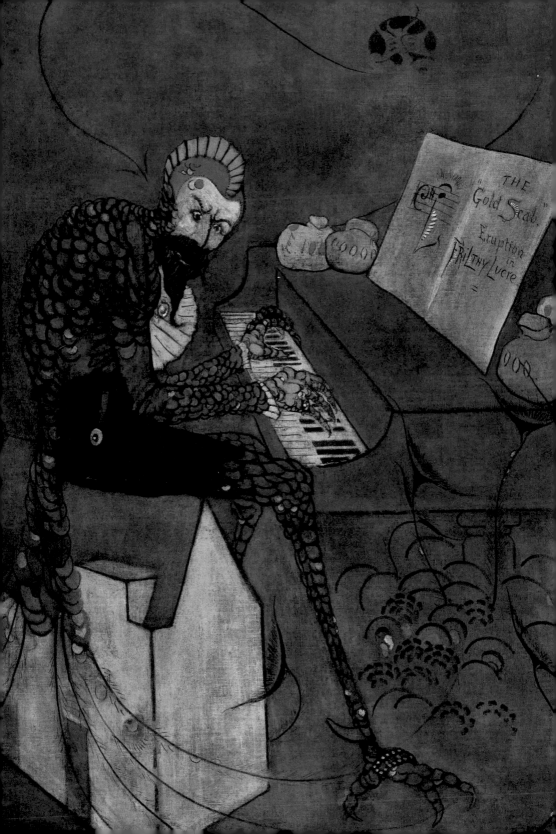

2

Pictor-pugnax: Whistler's 'Gentle Art'

James Robinson

In May 1879, the artist James Abbott McNeill Whistler was declared bankrupt. He was obliged to sell his beloved London home, the White House in Tite Street, Chelsea, together with its contents including his artworks. Among the paintings that fell to his creditors was a work unique in Whistler's painted oeuvre: *The Gold Scab: Eruption in Frilthy Lucre (The Creditor)* (fig.1). One of the few surviving comments made by contemporaries on this unusual work is that of E.W. Godwin, Whistler's friend and the architect of the White House, who wrote in 1882 that the painting was 'especially curious as illustrating the characteristics of our Pictor-pugnax', or pugnacious painter.[1]

Whistler's belligerent tendencies at this time were well known, not least through his very public disputes with Frederick Richards Leyland, an erstwhile friend and patron, collector and amateur pianist, and the art critic John Ruskin. It was the court case with the latter, whom he prosecuted for libel in 1878, which resulted in his bankruptcy. Although Whistler won the case he was awarded only a farthing in damages. Principal among his creditors was Leyland, and it is Leyland who is depicted in *The Gold Scab*. Shown perched on a model of the White House and playing the piano, he is wearing one of the frilled shirts for which he was known to have a particular predilection, prompting Whistler to coin the word 'frilthy' as part of the insinuating title. He is represented in horrific hybrid form, half-man half-peacock, leering wickedly out of the canvas. The painting was saturated with significance for Whistler and Leyland, and for the wider circle that had followed the dispute between them a few years earlier. It stands as unambiguous evidence of a relationship soured beyond redemption.

The situation had been very different when Whistler first painted Leyland in the early 1870s (fig.2). *Arrangement in Black: Portrait of F.R. Leyland*, inspired by the works of Velázquez, was a portrait of stately proportions, dignified by one of Whistler's characteristic titles derived from musical terminology. The emotional journey that produced two such radically different treatments of the same subject is explored in Darren Waterston's magisterial evocation of the Peacock Room, an interior originally commissioned by Leyland

1 page 28
James Abbott McNeill
Whistler (1834–1903)
The Gold Scab:
Eruption in Frilthy Lucre
(The Creditor), 1879 (detail)
Oil on canvas, 186.7 x 139.7 cm

The Fine Arts Museums of San Francisco: Gift of Mrs Alma de Bretteville Spreckels through the Patrons of Art and Music, 1977.11

2
James Abbott McNeill
Whistler
Arrangement in Black:
Portrait of F.R. Leyland,
1870–3
Oil on canvas, 192.8 x 91.9 cm

Freer Gallery of Art, Smithsonian Institution, Washington D.C.: Gift of Charles Lang Freer, F1905.100

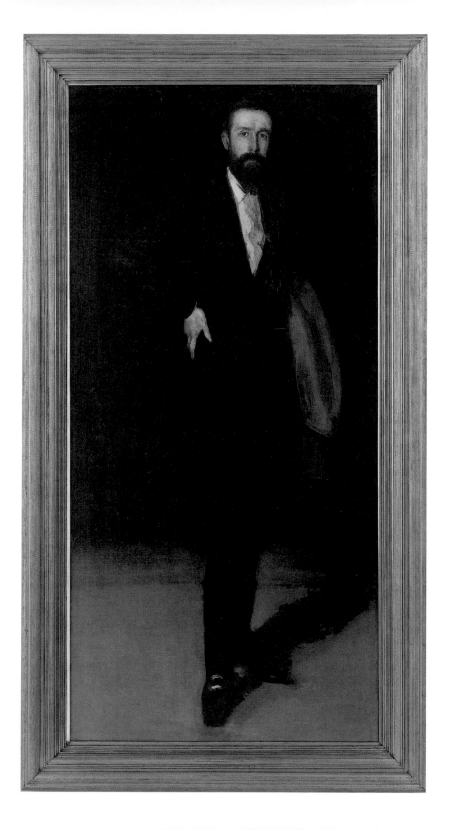

from the renowned architect Thomas Jeckyll and decorated with abandoned enthusiasm by Whistler between 1876 and 1877.

Filthy Lucre revisits the Peacock Room almost as if it were the scene of a crime. With a Hitchcockian sense of suspense, the drama has occurred off-stage and we, the visitors, are left to decipher what happened. Waterston has adhered to the original tonal values and proportions of the room, so that the first impression is one of a sumptuously beautiful interior. On closer inspection, however, it is soon clear that something is not quite right. The ceiling is slightly lower, creating a brooding sense of claustrophobia. Broken pots, splintered shelves that have buckled under an inexplicable strain, and dripping stalactites of gold that create oozing, scabrous surfaces, all speak of something sinister and toxic (fig.3). The room has been cleverly reimagined in a way that is at once architectural, sculptural, painterly and theatrical. Ghostly protagonists occupy every corner and crevice, their voices echoed in a soundscape that accompanies the installation. As the music of a melancholy cello seeps out of walls and painted pots, muffled voices punctuated by an eerie silence express mysterious statements or poignant sentiments held by Whistler, such as 'An artist's career always begins tomorrow'.

That music should be an integral part of *Filthy Lucre* is entirely appropriate, of course. Whistler famously experimented with the relationship between colour and music, devising titles for his paintings that expressed this interconnection. Thus, an individual work would be known as an 'arrangement', a 'symphony', a 'harmony', 'variation' or 'nocturne'. Whistler credited his friend Leyland, in 1872, with suggesting the use of the term 'nocturne':

> *I say I can't thank you too much for the name 'Nocturne' as a title for my moonlights! You have no idea what an irritation it proves to the critics and consequent pleasure to me – besides it is really so charming and does so poetically say all that I want to say and no more than I wish![2]*

3
Darren Waterston
Filthy Lucre, 2013–14
(detail of dripping stalactites of gold)

The declaration that causing irritation to critics was a positive source of pleasure for Whistler conforms to

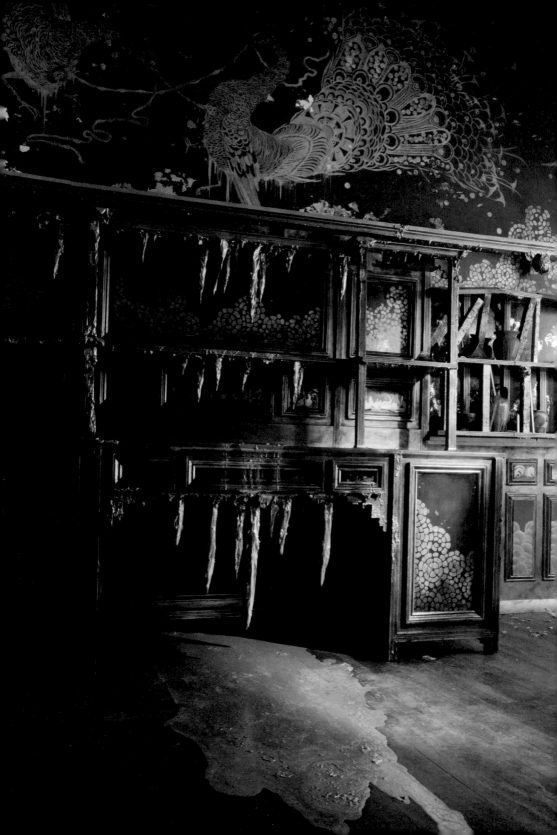

Godwin's later view of him as 'Pictor-pugnax'. The critics were duly voluble in their criticism, devising their own version of synaesthesia to deride Whistler's musically inspired titles and to express their distaste. Whistler's *Arrangement in Grey and Black: Portrait of the Painter's Mother* of 1871, when exhibited the following year, became for the *Daily Telegraph* a poisonous soup of 'Warren's blacking, diluted with skimmed milk'; his *Variations in Flesh Colour and Green: The Balcony* of 1864–70, when exhibited at the Grosvenor Gallery in 1877, became a picture of 'Bacon and Spinach' or 'Ham and Peas' to the reviewer in *Punch*.[3]

Whistler was one of a number of personalities emphatically at the centre of what is generally termed the Aesthetic Movement. The popular perception of this avant-garde, which included among others the Pre-Raphaelite painter Dante Gabriel Rossetti and the playwright, author, poet and essayist Oscar Wilde, was heavily influenced by *Punch*, a publication that delighted in parodying Aesthetic taste and values. The cartoonist George du Maurier was a primary exponent of this style of humour, contributing satires on the subject to *Punch* from 1873 to 1881 that systematically poked fun at the Aesthetes' love of flowers (particularly lilies and sun-flowers), blue china (see pp.80–1) and Japanese fans. It is within this general climate of scathing parody and biting wit (fig.5) that Whistler's predisposition to wield the pen or the paintbrush to equally satiric effect can best be understood. It is no surprise at all that when his relationship with Leyland ended, Whistler employed the sharpest weapon in his arsenal to humiliate his enemy, namely his artistry (fig.4). The events leading up to the rupture between Leyland and Whistler are well recorded, although speculation lingers with regard to certain underlying tensions between them.

Leyland, a wealthy shipping magnate from Liverpool, first met Whistler in the late 1860s and soon became the artist's most generous patron, supporting Whistler's first solo exhibition at the Pall Mall Galleries in 1874. In the same year, Leyland took the lease on 49 Prince's Gate in London, where he was determined to establish a verita-ble palace of art to showcase his extensive collection of paintings, tapestries, carpets and ceramics. Whistler was appointed to decorate the dado panels in the

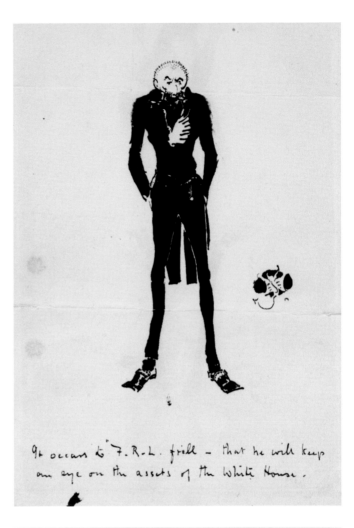

4

James Abbott McNeill
Whistler

***Caricature of F.R. Leyland,
1879***

Pen and ink on paper,
17.4 x 11.2 cm

After his bankruptcy, Whistler
rendered this caricature of
Leyland, now his creditor. The
text reads: 'It occurs to F. R.
L. frill – that he will keep an
eye on the assets of the
White House.'

5

Caricature of Whistler

'Drawn by Alfred Thompson.
The Mask. 31 May. 1879'
Presscutting

Whistler is shown with his
trademark tuft of white hair
in tight-fitting trousers and a
stars-and-stripes tunic. A
peacock feather and his
butterfly signature offer
further clues to his identity.

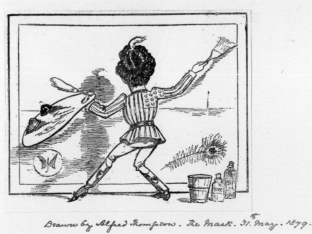

6 below
James Abbott McNeill
Whistler
**Dado panel from the
staircase at 49 Prince's Gate,
London, 1876**
Paint and metal leaf on wood,
64.7 x 50.1 cm

V&A: W.35-1922

7 opposite
Thomas Jeckyll (1827–1881)
Section of railing, 1876
Wrought iron, 77 x 27 cm

V&A: CIRC.530-1953

hallway and its sweeping staircase (fig.6). Here he used a treatment known as Dutch metal, an alloy of copper and zinc that oxidized to a deep green-gold colour, fixed with a glaze. The architect who was engaged to make the major modifications to the house, including the study and the dining room (later redesigned by Whistler as the Peacock Room), was Thomas Jeckyll.

Jeckyll was a leading proponent of the Anglo-Japanese style, known as 'Japonisme'. He had come to prominence through significant commissions such as the new wing for the London residence of the collector Alexander Ionides at 1 Holland Park in 1870 and the cast-iron pavilion for the 1876 Philadelphia Centennial Exhibition, which was subsequently rebuilt for the 1878 Exposition Universelle in Paris. Among the notable features of this latter structure was a ground-level railing, consisting of sunflowers modelled in wrought iron (fig.7). Jeckyll's design reaffirmed the sunflower as an emblem of the Aesthetic Movement (fig.8) and was later adapted, in the form of firedogs, for Leyland's

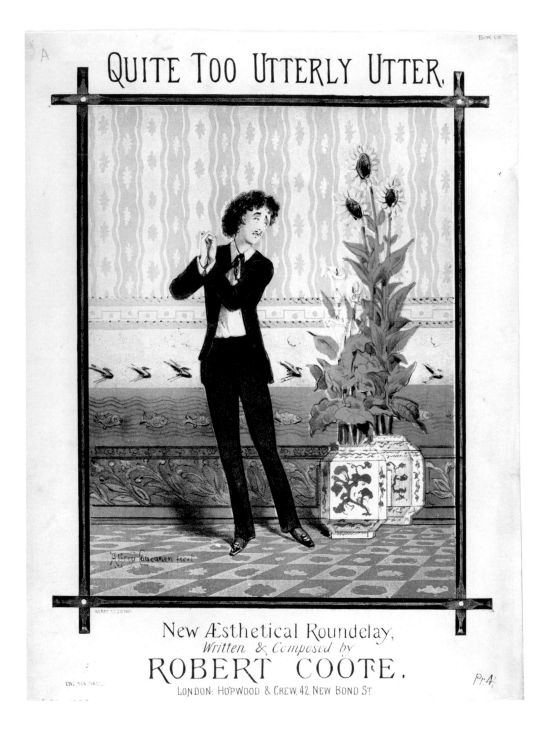

8
Alfred Concanen (1835–1886)
Quite Too Utterly Utter,
*c.*1881
Paper sheet-music cover
Colour lithograph,
36 x 26 cm

V&A: S.34-1993

A distinctly Whistler-like
figure is shown in adoration
of sunflowers that stand in
the ubiquitous blue-and-
white porcelain pots.

9 overleaf
Darren Waterston
Filthy Lucre, 2013–14
(detail of firedogs)

Peacock Room (fig.11). In *Filthy Lucre*, Waterston's ren-
dition of these fixtures is emphatically mournful as the
pitted metal appears to wilt and wither in a moment of
molten decay (fig.9).

The Peacock Room takes its name from Whistler's
painted peacocks, which decorate its walls and shutters,
and the decorative motifs that cover the panelling,
cornices and vaulted ceiling, as well as the overall irides-
cent colours that shimmer from green to gold
throughout. However, when Jeckyll originally designed
the room, he had a very different concept in mind. He
had been instructed by Leyland to create a suitable
space in the dining room for his extensive blue-and-
white porcelain collection. Leyland had been introduced
to the craze for collecting Chinese porcelain by Whistler
and Rossetti, and acquired pieces en masse almost
exclusively from the dealer Murray Marks. There were
two other critical components that had to be integrated
into the room: a series of rare eighteenth-century gilt
leather wall panels and Whistler's painting of *La*
Princesse du pays de la porcelaine (*The Princess from*
the Land of Porcelain) (fig.10). Antique leather wall
panels were widely considered to be quite the best
background for blue-and-white porcelain, while
Whistler's *Princesse*, with the exotic allure of its central
character, was a suitable enhancement for a room that
to all intents and purposes would serve as a
Porsellanzimmer, or porcelain cabinet. These first
emerged in the early seventeenth century in the aristo-
cratic palaces of Germany and then quickly spread
throughout Europe, due to the influx of vast quantities
of Chinese porcelain imports that were greedily col-
lected by the very wealthy at that time. Jeckyll designed
a complex wooden infrastructure to support the weight
of load-bearing shelves and to which the eight-
eenth-century gilt leather could be attached. Walnut
spindle shelving, incised with patterns from Chinese and
Persian sources, was arranged over this structure to
display Leyland's blue-and-white china.

Although Jeckyll's dining room was heavily indebted
to Chinese and Persian ornament, it also relied on motifs

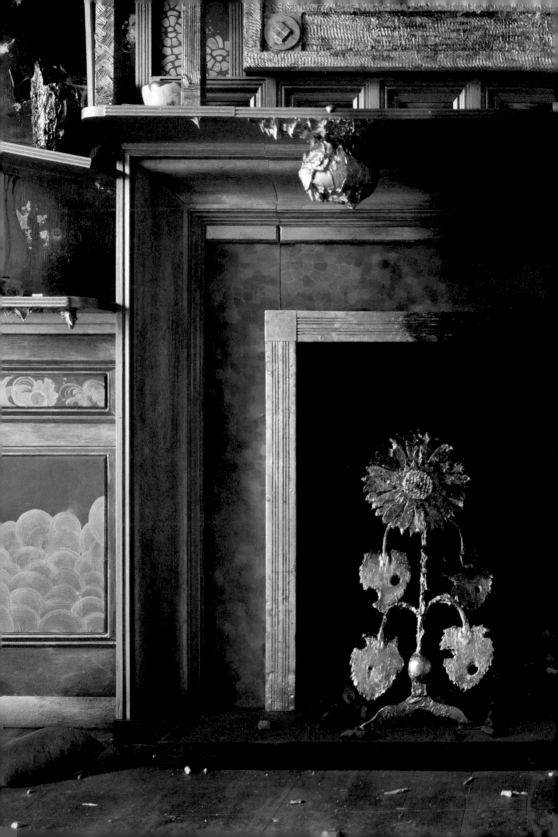

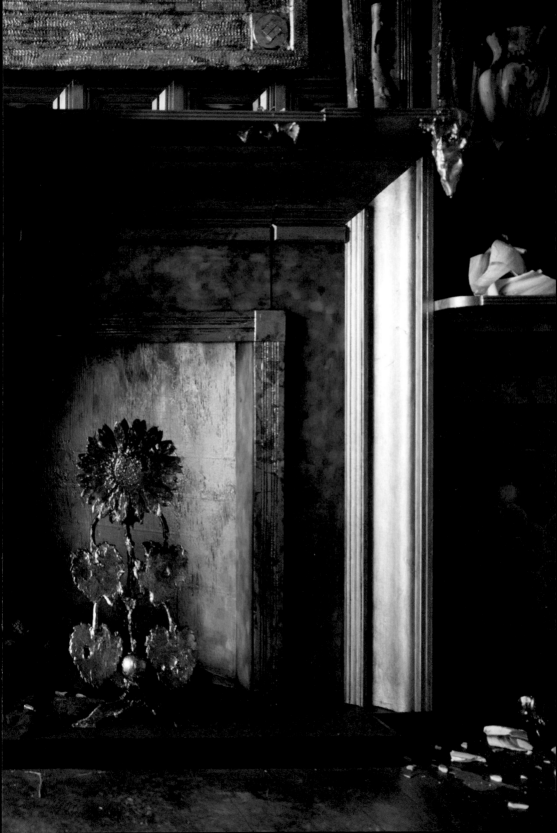

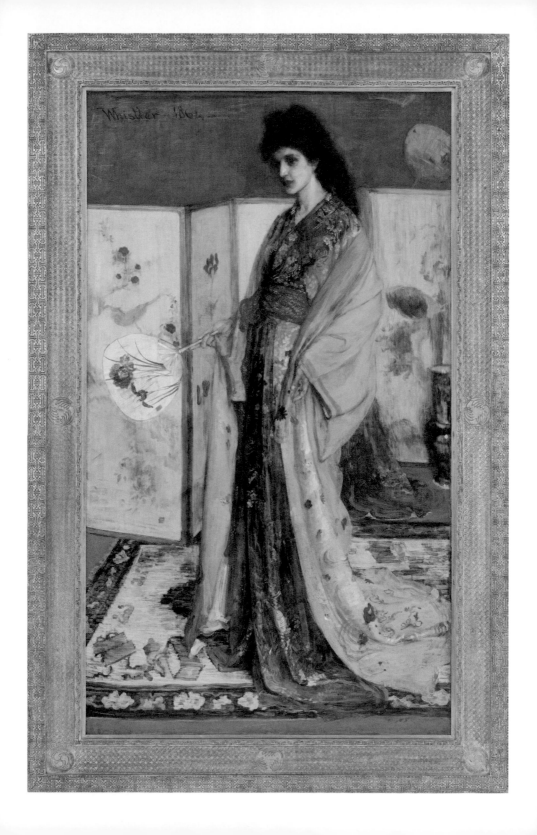

10
James Abbott McNeill
Whistler
*La Princesse du pays de la
porcelaine*, 1863–5
Oil on canvas, 201.5 x 116.1 cm

Freer Gallery of Art, Smithsonian
Institution, Washington D.C.: Gift of
Charles Lang Freer, F1903.91a-b

11 overleaf
**The Peacock Room, 1876–7,
now installed at the Freer
Gallery of Art**
Oil paint and gold leaf on
leather, canvas and wood

Freer Gallery of Art, Smithsonian
Institution, Washington D.C.: Gift of
Charles Lang Freer, F1904.61

The Peacock Room is here
shown installed with blue-
and-white porcelain dating
to the Kangxi period (similar
to that which Leyland would
have displayed) alongside
recently commissioned
pieces.

that were drawn from Jacobean sources, such as the double-panelled dado. The wood and canvas ceiling was made to simulate lierne vaulting of the early sixteenth century, also known as stellar vaulting due to the star-shaped motifs that are produced by the alignment of the ribs. At the centre of each 'star', Jeckyll placed the most exquisite pendant gas lamp with a metal mount pierced with Chinese-inspired decoration (fig.12).

The room was more or less complete by April 1876 when Leyland wrote to Whistler about the colour scheme, suggesting that Whistler's use of Dutch metal might suit the leather rather better than the yellow-and-white colour combination proposed by Jeckyll. At about this point, Jeckyll succumbed to a mental illness that had troubled him in the past and had to withdraw from the commission. Whistler set to work covering the shutters, door, dado and wainscoting in the green-gold finish that he had used to such good effect in the hall and stairway. With Leyland's permission, he also began to apply yellow paint to the Rococo-style red roses in the leather panelling, which he felt clashed with the pink sash of his *Princesse*.

However, left to his own devices, Whistler over-stepped his initial instructions and began to turn his attention to the rest of the room, gradually over-painting it in its entirety with great relish. He developed a series of Japanese fan or wave patterns, inspired by the leaded lights of Jeckyll's service door, and these evolved into peacock feather motifs that spread over the walls, cornice and ceiling. He gilded the walnut shelving and painted golden peacocks on the shutters. Leyland's response to the work was less than rapturous. He maintained that Whistler had exceeded his brief and refused to settle the full amount, finally paying no more than half of the £2,000 that Whistler had demanded. Furious at Leyland's attitude, Whistler returned to complete work on the Peacock Room and painted over the precious antique leather panels in tones of Prussian blue and gold, so as to achieve greater colour harmony in the room as a whole. This act effectively obliterated the final vestiges of Jeckyll's original scheme.

Jeckyll is undoubtedly another ghost inhabiting the room in Waterston's *Filthy Lucre*, his work defaced, overshadowed and almost forgotten due to Whistler's

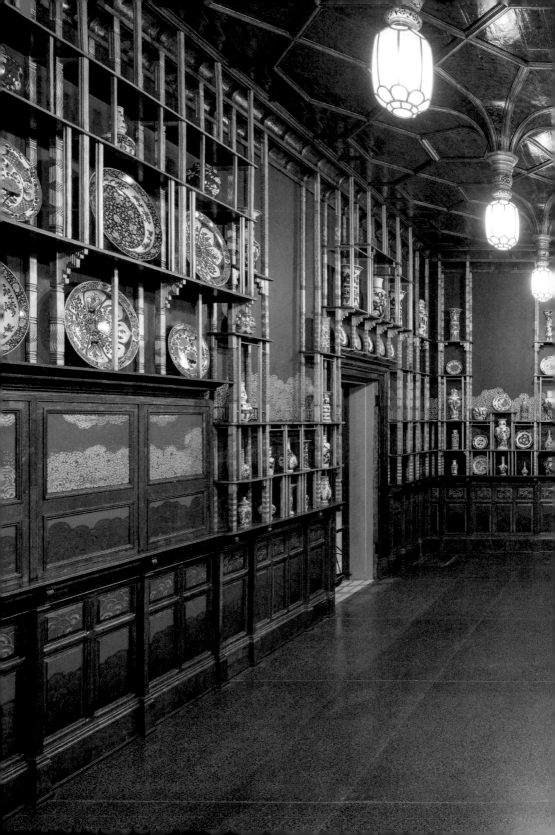

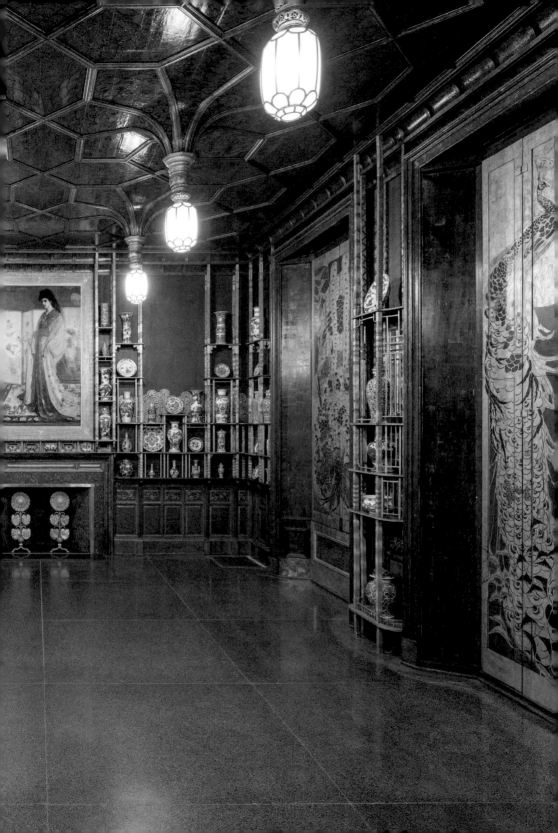

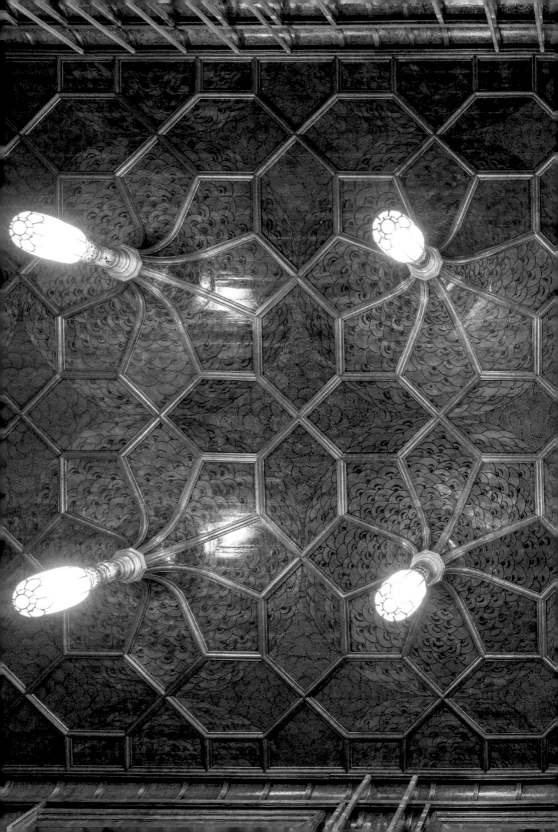

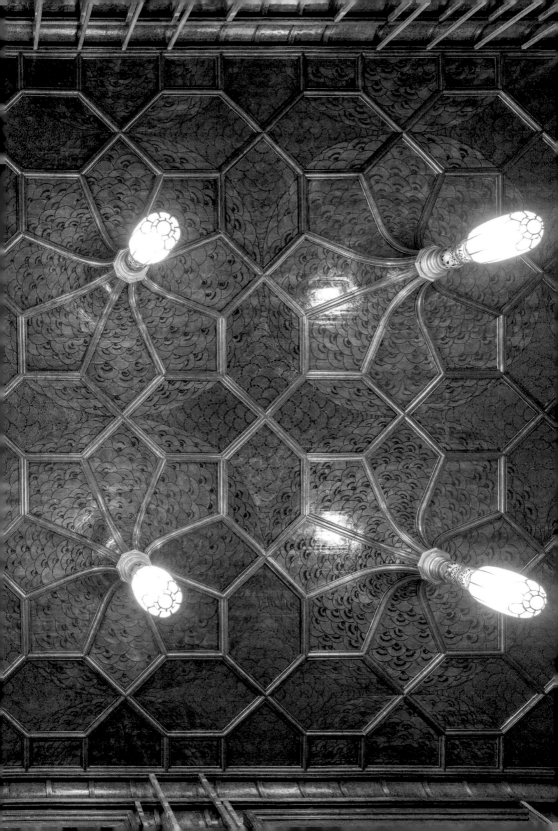

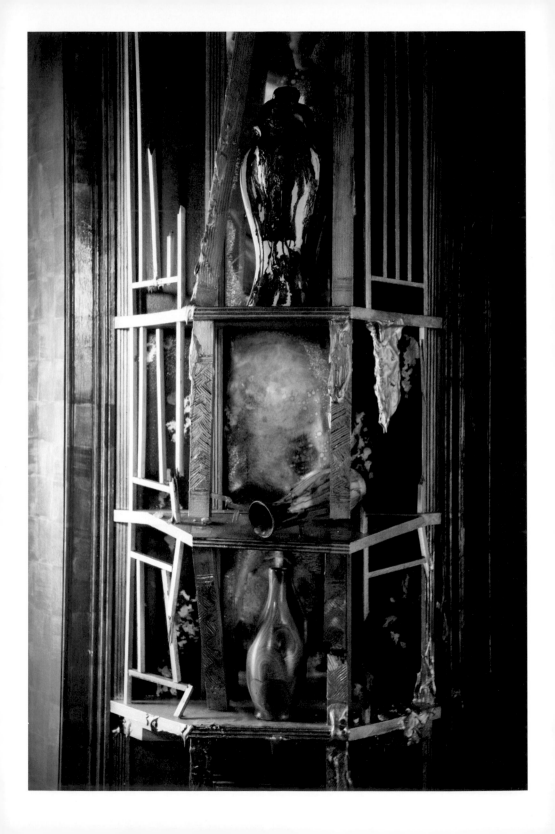

12 previous page
The Peacock Room, 1876–7
(detail of ceiling)

Freer Gallery of Art, Smithsonian
Institution, Washington D.C.: Gift of
Charles Lang Freer, F1904.61

intervention. The shelves, splintered and broken, serve as a metaphor for Jeckyll's frail mental state as they collapse and fall without the infrastructure that he provided to support them (fig.13). Poignantly, Leyland's dining room at 49 Prince's Gate was Jeckyll's final commission. He spent the remaining five years of his life institutionalized, finally dying in 1881.

The decoration of the Peacock Room was still lacking one vital element. In 1867, Leyland had commissioned a work from Whistler entitled *The Three Girls*, which was to hang in the dining room opposite *La Princesse du pays de la porcelaine*. Whistler had struggled to complete the painting and now used the space instead to vent his fury against Leyland. He painted two fighting peacocks, their wings extended in a flurry of rage. The peacock on the right, with its tail feathers outstretched, was intended to represent Leyland, coins on its breast and at its feet; the peacock on the left, turning to confront its adversary, is Whistler (fig.14). The meaning is made explicit in Whistler's comments to Leyland:

> *It is positively sickening to think that I should have labored to build up that exquisite Peacock Room for such a man [as you] to live in! ... The World only knows you as the possessor of that work they have all admired and whose price you refused to pay – I refer you to the Cartoon opposite you at dinner, known to all London as 'L'Art et L'Argent' or the Story of the Room.*[4]

Whistler named the room as though it were an easel painting – *Harmony in Blue and Gold: The Peacock Room* – and did his utmost to publicize his masterpiece, organizing a press view before Leyland banished him from 49 Prince's Gate forever.

The violence of the encounter between the battling peacocks, between Art and Money, is given a truly 'gloves-off' treatment in Waterston's rendering of the scene. His peacocks retain the sinuous elegance and balance of Whistler's original work but the attack is more brutal: feathers and coins fly in a frenzy as the birds, very beautifully, disembowel one another (fig.15).

Whistler asserted, when challenged by Leyland about over-extending his remit in the Peacock Room,

13
Darren Waterston
Filthy Lucre, 2013–14
(detail of ceramic display on splintered shelves)

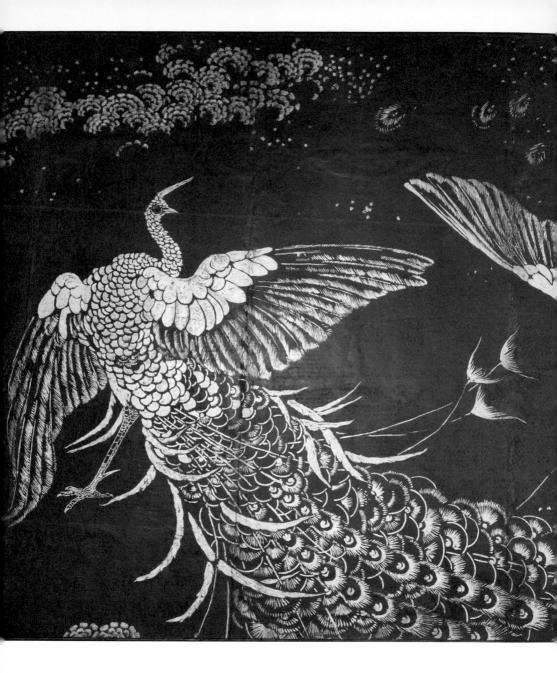

14
**The Peacock Room, 1876–7
(detail of fighting peacocks)**

Freer Gallery of Art, Smithsonian
Institution, Washington D.C.: Gift of
Charles Lang Freer, F1904.61

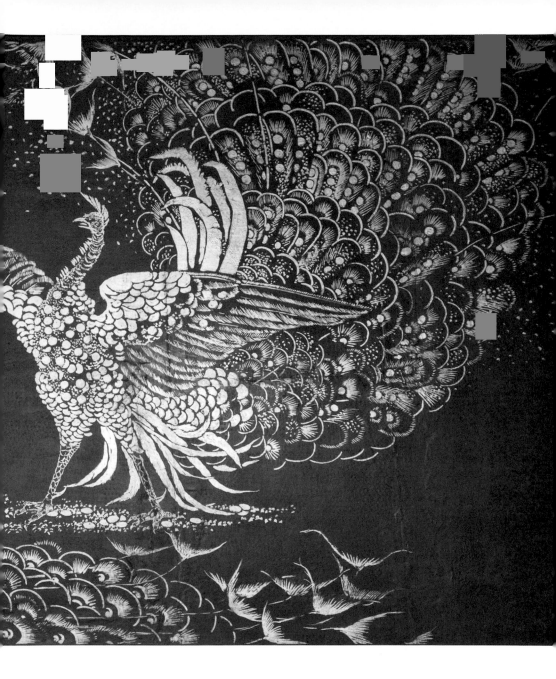

15 overleaf
Darren Waterston
Filthy Lucre, 2013–14
(detail of fighting peacocks)

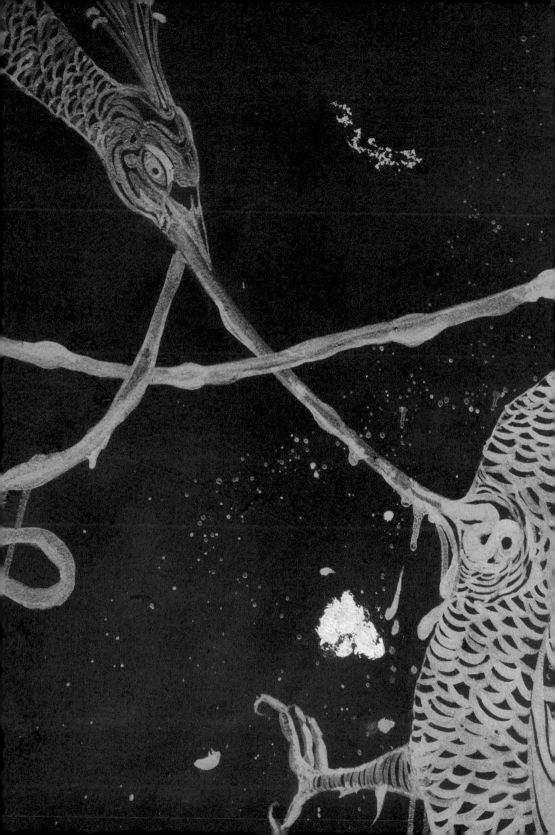

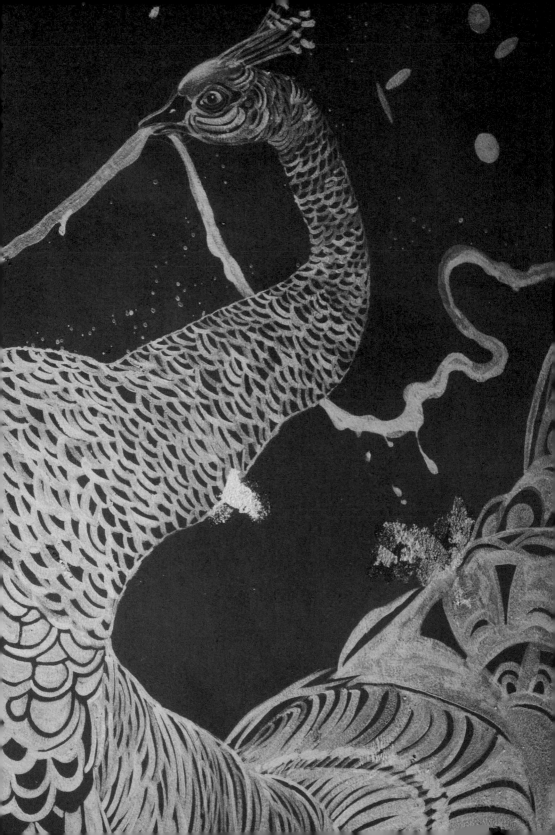

16
James Abbott McNeill
Whistler
**Sketches of the Peacock
Room, 1876**
Pen and brown ink on double
sheet of off-white laid paper,
31.9 x 20.3 cm

The Hunterian, University of Glasgow:
GLAHA 47070a-d

that 'I just painted it as I went on, without design or sketch'.[5] However, a number of sketches survive that might imply a rather different process. Pen sketches of the Peacock Room's south wall and shutters, roof and wall panelling, pendant gas lamps and cove, as well as the two fighting peacocks, could suggest some preparatory work (fig.16). Equally, it is also argued that they may comprise a record by Whistler, made from memory after he was denied access to the house in Prince's Gate. What is less ambiguous is Whistler's cartoon, *The Rich and Poor Peacocks*, which formed part of the significant bequest in 1958 to the Hunterian Art Gallery in Glasgow by his ward, Rosalind Philip (née Birnie). Designed and painted after his quarrel with Leyland, Whistler's wonderfully animated drawing is an accurate representation of his final composition and has been pricked for

transfer to the wall (fig.17). While the early stages of Whistler's decoration of the Peacock Room may have been spontaneous, clearly when it came to the ultimate denouement, embodied in the vitriolic satire *Art and Money; or, the Story of the Room*, Whistler's revenge was more carefully planned.

Further colloquial evidence survives that presents the Peacock Room as an incomplete, unrealized ambition for Whistler. If Leyland and Whistler had not fallen into dispute over the room, and if Whistler had been given full artistic autonomy, it is likely that instead of battling peacocks a much more harmonious scene would have unfolded. The American printmaker Otto Bacher maintained that Whistler planned the painted equivalent of a musical crescendo for the room in a picture that he intended to entitle *Full Palette*. Bacher

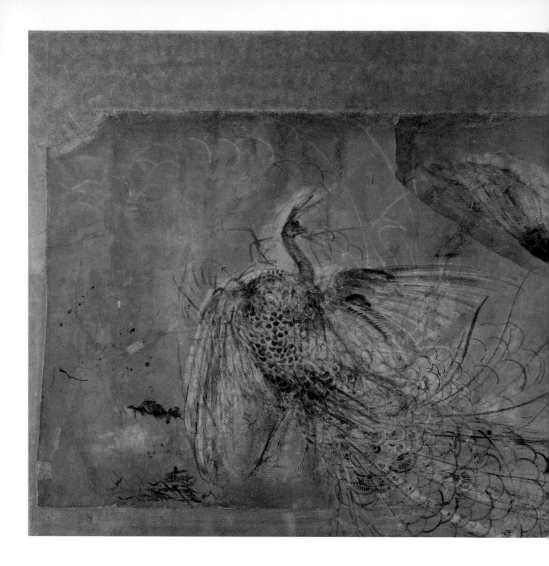

17
James Abbott McNeill Whistler

Cartoon of *The Rich and Poor Peacocks,* 1876
Chalk and wash on brown paper pricked for transfer, 181 x 389.2 cm

The Hunterian, University of Glasgow: GLAHA 46071

recounts Whistler's aim: 'If I can find the right kind of thing I will produce a harmony in colour corresponding to Beethoven's harmony in sound.'[6]

It is a curious but undeniable fact that despite the acrimony that flared up between artist and patron, Leyland appears to have appreciated the value of Whistler's work. He might have been in a position to destroy not only the *Art and Money* satire but also, as one of Whistler's creditors, *The Gold Scab: Eruption in Frilthy Lucre*. In fact he reversed none of Whistler's changes and continued not only to dine in the room but also to grant admission to visitors and critics alike,

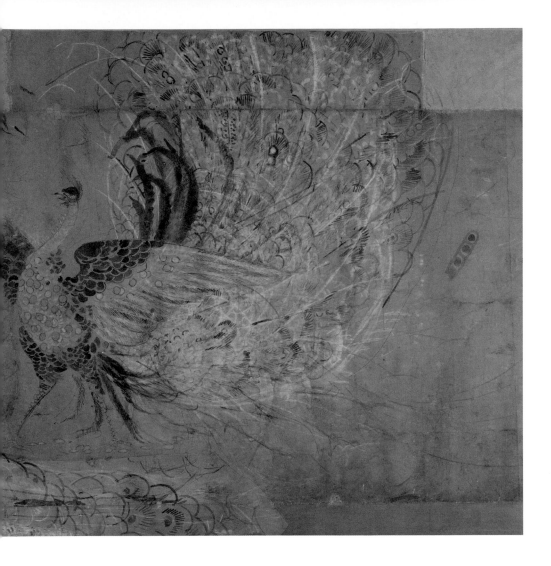

including the architectural photographer Harry Bedford Lemere (fig.19), so keeping the reputation of the Peacock Room alive long after Leyland's own death in 1892. Among the artists who Leyland admitted was Aubrey Beardsley in 1891. The impact of this visit on Beardsley's work can be clearly evidenced in *The Peacock Skirt*, reproduced in Oscar Wilde's *Salome* in 1894 (fig.18).

Whistler continued to quarrel and cajole in the law courts, through personal correspondence and publications, alienating in due course his former friends Oscar Wilde and Algernon Charles Swinburne, the poet and

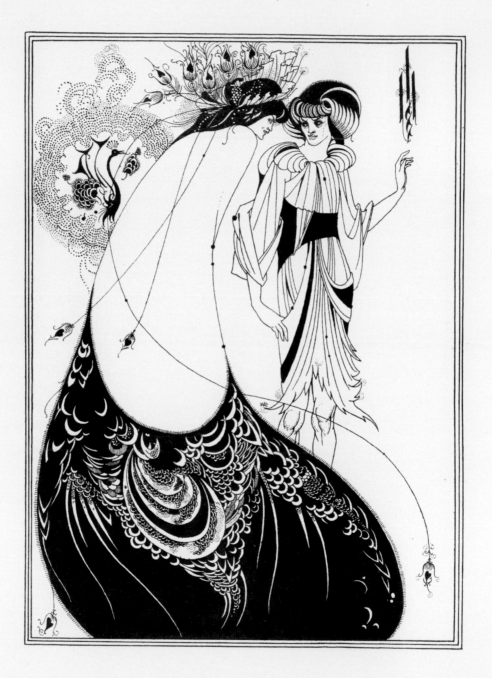

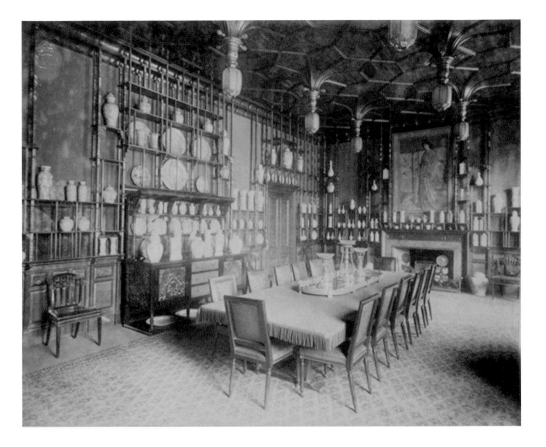

18
Aubrey Beardsley
(1872–1898)
The Peacock Skirt, 1894
Line block print, 34.4 x 27.2 cm

V&A: E.426-1972

19
Harry Bedford Lemere
(1864–1944)
The Peacock Room, 1892
Albumen print, 26.2 x 32.8 cm

V&A: 240-1926

critic. In 1890, Whistler celebrated his own pugnacious character in his publication, *The Gentle Art of Making Enemies*. He died in 1903, whereupon the prices for his works soared. The following year, the Peacock Room was acquired by the Detroit industrialist and art collector Charles Lang Freer, a patron of the artist. The entire room was shipped across the Atlantic in 27 crates, to be reassembled in a specially built annex in Freer's Detroit home. The *Chicago Tribune*'s headline for 4 September 1904 read: 'Whistler's Peacock Room. World's Greatest Masterpiece of Decorative Art Bought by an American'.[7] Following Freer's death in 1919, the Peacock Room was transported to Washington D.C. and installed in the Freer Gallery of Art, where it remains.

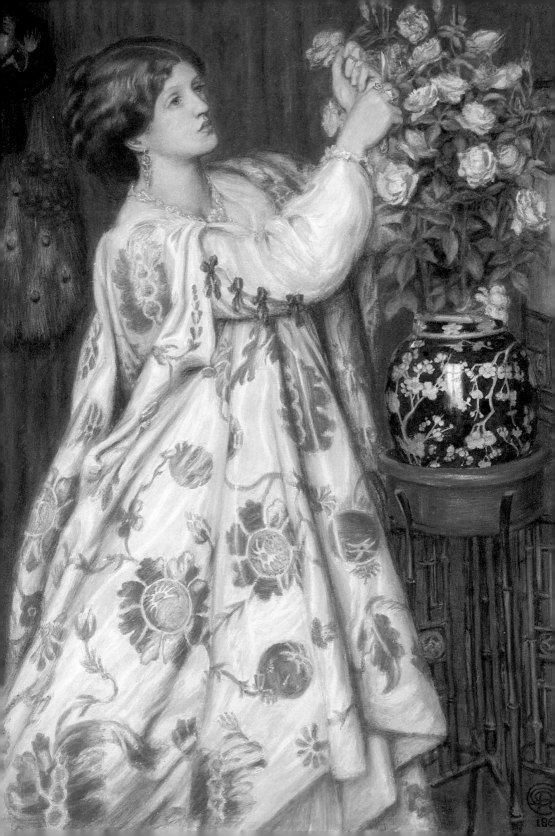

3

Chinamania:
The Passion for
'Blue and White'

Florence Tyler

20 page 60
Dante Gabriel Rossetti
(1828–1882)
Monna Rosa (portrait of
Frances Leyland), 1867
Watercolour, pencil and
bodycolour on paper,
57 x 40.7 cm

Private collection

21 and 22 below and
opposite
Darren Waterston
Filthy Lucre, 2013–14
(details of ceramics)

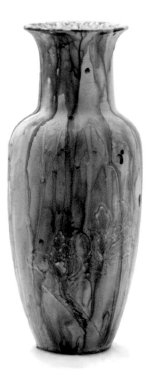

The ceramic presence looms large in *Filthy Lucre*, Darren Waterston's exuberant yet eerie reimagining of Whistler's Peacock Room. The installation forefronts the room as a site of ceramic display, in keeping with its original purpose to house the impressive collection of antique Chinese blue-and-white porcelain belonging to Frederick Richards Leyland, and subsequently the collection of Asian ceramics owned by American industrialist Charles Lang Freer. Yet in place of pristine porcelain we are confronted with broken vessels: ghosts, memories or warnings of the room's history as a place of both material beauty and spiritual ruin. Waterston's bold and colourful ceramics, handpainted specially for the installation using pots found in attics of friends' houses or junk shops, are found shattered on the floor in pieces, or else perched precariously on dislocated shelves, appearing to head towards a similar fate (figs 21, 22). Nothing shocks quite like the sudden and irreversible smash of a ceramic object, especially one to which we ascribe historical, cultural or sentimental value, a theme famously explored in Ai Weiwei's *Dropping a Han Dynasty Urn* (1995), in which he photographed himself dropping a 2,000-year-old urn to the floor without emotion, allowing it to smash to pieces. Interrogating the value we assign to art and objects is a notion pertinent to *Filthy Lucre*, a dark and alternative vision of a room that embodies conflicts of artistic, social and monetary value – felt most vividly in Leyland's refusal to pay Whistler in full for his work. The excessive care and pride with which Leyland and his contemporaries looked after their precious collections of 'blue and white' is replaced with a scene of neglect, disorder and decay. Waterston's fractured ceramics symbolize an obsession with material goods that has quite literally reached breaking point, drawing parallels with the criticisms slung at those Aesthetes who were seen to value blue-and-white porcelain over all else: the victims of so-called 'Chinamania'.

The passion for collecting antique blue-and-white china, otherwise known as 'Nankin' or 'Old blue', reached extreme heights in the second half of the nineteenth century, when these pieces were discovered and exalted by a small group of artists and intellectuals engaged in the 'search for beauty'. Seen to embody true beauty in

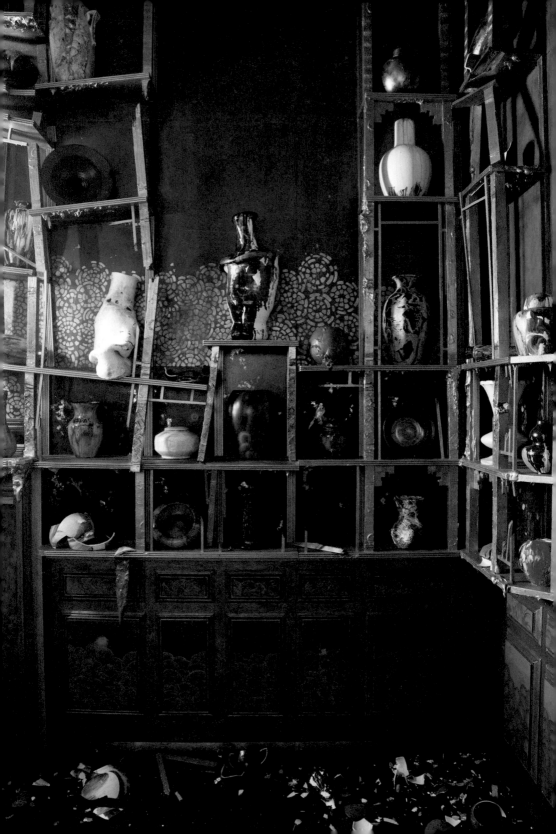

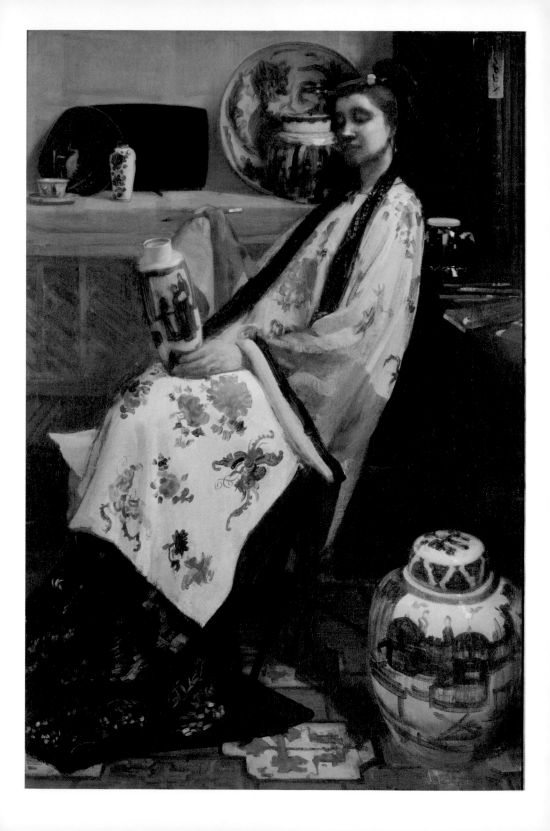

colour, material and form, Whistler bought his first pieces of blue and white in Paris and Amsterdam in the early 1860s, his fixation on these objects so strong that he confessed to 'ruining' himself with old china. Bringing these treasured items back to London, he ignited a spark amongst his artist friends, in particular the Pre-Raphaelite painter Dante Gabriel Rossetti, who, having owned one or two pieces beforehand, now eagerly began to collect. With the help of Murray Marks, a knowledgeable dealer with connections in the Netherlands where much of this antique china was available, a close circle of artists and wealthy businessmen began to surround themselves with blue and white. The status of these pieces as desirable objects worthy of admiration was furthered by their inclusion in paintings as decorative props, as seen in Rossetti's portrait of Leyland's wife, Frances, titled *Monna Rosa* (fig.20), in the background of Whistler's *La Princesse du pays de la porcelaine* (displayed in the Peacock Room; fig.10), or more conspicuously in Whistler's painting *Purple and Rose: The Lange Leizen of the Six Marks* (fig.23). Here, an elegant woman in Japanese dress sits languidly painting a vase, surrounded by fine specimens of blue and white based on those Whistler owned, including a ginger jar now in the V&A collection (fig.24).

Although from the 1860s onwards the popularity and taste for Chinese ceramics was singularly driven by those in the Aesthetic Movement, an appreciation of 'oriental' blue and white was not new in Europe. From the sixteenth century Chinese ceramics were present amongst the collections of English aristocracy, and with the founding of the Dutch East India Company in 1602, Chinese and Japanese ceramics were made expressly for export to Western clients and traded into Europe in large quantities throughout the seventeenth century. The wide appeal of these wares is evidenced by the simultaneous production of tin-glazed earthenware in Delft, the Netherlands, where factories would reproduce the blue-and-white colour combination in Chinese styles, often copying designs directly yet in a cheaper and less refined material. Porcelain was deemed an exquisite clay of far superior quality, which held a mysterious fascination in the West given that homegrown manufacturers had hitherto been unsuccessful in their

23
James Abbott McNeill Whistler
Purple and Rose: The Lange Leizen of the Six Marks, 1864
Oil on canvas, 93.3 x 61.3 cm

Philadelphia Museum of Art, Pennsylvania / John G. Johnson Collection, 1917: Cat.112

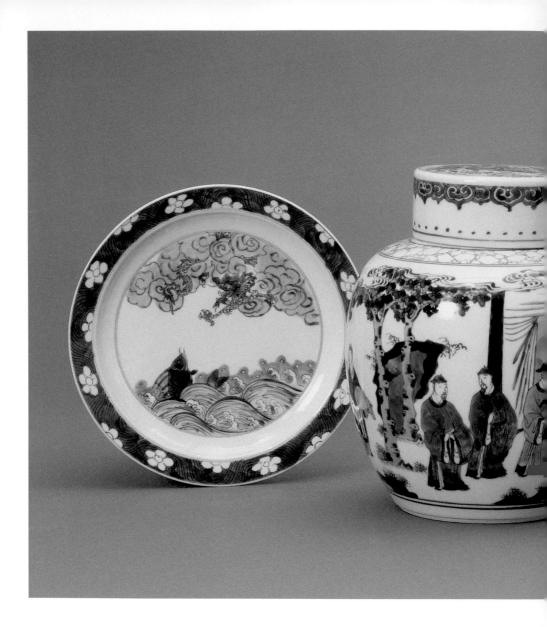

24

Plates, ginger jar and vase owned by Whistler and Rossetti

China, Qing dynasty,
Kangxi period, 1662–1722
Porcelain painted in
underglaze blue;
Diam. 20.8 cm; H 23 cm;
H 26.8 cm; Diam. 20.8 cm

V&A: C.770-1910; C.836&A-1910; C.935-1910; C.769-1910

attempts to produce it. Thus, the fashion for Chinese porcelain thrived until ceramic manufacturers in England and continental Europe began to master and successfully market their own porcelain, resulting in the gradual decline of Chinese exports in the late eighteenth and early nineteenth centuries. This coincided with a 150 per cent duty on Chinese porcelain to protect factories in England, further discouraging the taste for these wares.[1]

The resurgence of interest in East Asian art later in the nineteenth century was primarily enabled by newly established treaties with China and Japan, which opened up more ports and reduced tariffs for foreign trade. The Treaty of Tianjin and the Anglo-Japanese Treaty of Amity and Commerce were both signed in 1858, and would later become known as two of the 'unequal treaties' signed with Western powers during this period. An influx of goods followed, and after 200 years of Japanese isolation, this new wave of imports had an immense impact on those in Aesthetic circles as well as the wider British public, stimulating a fervent predilection for all things Japanese, known as 'Japonisme'. A landmark event for this phenomenon was the London International Exhibition of 1862, which increased public awareness of the arts of Japan by presenting the largest display of Japanese art ever seen in Europe.[2] At a time when contemporary British manufacture was largely condemned as substandard and in need of major design reform, the arts of Japan satisfied the growing appetite for well-crafted handmade goods, a reaction against the 'weak' and 'ugly' products of industrial mass production. These goods were of particular appeal to those with Aesthetic sensibilities, who believed that the Japanese 'lived a life in harmony with nature, with art and beauty overriding material considerations'.[3] Japanese woodcuts, furniture, ceramics, metalwork and textiles all offered an exotic, elegant and sensual material world that stood in contrast to what the *Burlington Magazine* described in 1882 as 'the barbaric horrors of the early Victorian period'.[4]

The effect of Japonisme on Whistler was profound, not only in his blue-and-white collecting habits (Whistler, like many others, confused the arts of China and Japan) but also in his paintings, adopting Japanese principles of composition and creating artificial scenes

with kimono-clad women set amidst china and other 'oriental' ornaments, as seen in figs 10, 23. In the field of ceramic manufacture, the influence of East Asia was deeply felt by British designers, who sought to meet consumer demand for the cult of Japan in both industrial factories and smaller art potteries. Richard William Binns, Art Director at the Worcester Porcelain Factory, became an enthusiast for the arts of Asia after visiting the International Exhibition of 1862, amassing his own collection of East Asian ceramics and encouraging his designers to use them as inspiration in their own designs. A pair of vases designed by James Hadley in 1872 typify this imaginative application of East Asian style, with the ceramic surface imitating dark lacquer and inlaid ivory (fig.25). The scenes depicted are none other than groups of potters making bowls and large vases, the very objects so fetishized by Aesthetes at this time. In revealing and revering the process, Hadley acknowledges the people as well as the pots, perhaps a knowing hint that in the Aesthetic consideration of beauty, material goods are often venerated in a state of total detachment from the people who made them.

25
Pair of vases, 1872
Designed by James Hadley (1837–1903) for the Royal Worcester Porcelain Factory
Porcelain painted with enamels and gilded, H 26.8 cm

V&A: 845-1872; 845A-1872

Elsewhere, in the emerging art potteries where increased focus and credit was given to the individual artist, Japanese motifs such as stylized flowers in balanced compositions were combined with existing production methods, as in the stoneware vessels of the Martin Brothers (fig.26). Despite the proliferation of Japanese-style goods in Britain, very few British artists or designers had travelled to Japan, with the exception of Christopher Dresser, one of the most significant designers and art educators of the nineteenth century. A trip to Japan in 1876–7, on behalf of the South Kensington Museum (now the V&A), gave Dresser valuable exposure to the production methods of Japanese arts and crafts, and deepened his understanding of material, form and manufacturing techniques. The impact of this visit, and his close relationship with the South Kensington Museum and its collections, can be seen in his later designs, in particular a bold 'double-gourd' vase with rich semi-lustrous green, brown and blue glazes made at the Linthorpe Pottery around 1880. The vase closely resembles a sinuous, probably Meiji-era, patinated bronze vase acquired by the Museum some four years earlier, which has clearly influenced Dresser's design (figs 27, 28). Although in 1878 an Aesthetically inclined home decoration manual claimed that (in relation to dinner services) 'the fashion for Japanese art produced attempts at imitation so dreadful, that one wished manufacturers had never heard of Japan',[5] it is possible to see that for those with the talent and ingenuity to experiment with shape, form and surface treatment within smaller art potteries, there was a positive and progressive creative influence to be gained from Japanese art.

The remark about 'dreadful imitation' reflects a sentiment echoed by many that industrial mass production had caused a severe dilution in the quality of contemporary manufacturing. The effect of 'ugly' things on one's being, in combination with the dehumanizing, poor working conditions associated with factory production, was of grave concern to those who identified with both Aesthetic and Arts and Crafts ideals. A further damning statement on the state of decorative art is found in one of Mrs Loftie's household advice manuals: 'Every season we have such things produced by the thousand, and

26
Vase, 1899
Made by the Martin Brothers
Salt-glazed stoneware with
incised decoration,
H 26.4 cm

V&A: C.465-1919

chiefly in the form of drawing-room and dining-room ornaments. People who buy them must remember that they are doing nothing for the encouragement of art: while at home they are doing much for the deterioration of taste'.[6] In the same series, entitled 'Art at Home', another writer laments 'how it is a sad and acknowledged fact that modern decorative art, at home or abroad, cannot compare in delicacy, conscientiousness, or knowledge, with that of past times'.[7] The idolization of pre-industrial methods of manufacture and the longing to possess only beautiful objects were two intertwined notions that help to explain the immediate appeal of antique blue-and-white china to Whistler, Rossetti, and the expanding middle classes from the 1860s onwards. These objects from 'past times' predominantly dated from the Kangxi period (1662–1722) of the

Qing dynasty, a pre-industrial society in which exquisite ceramics were made and decorated by hand with consummate skill, each one unique. Their 'indefinable charm' also lay in their universally attractive colour combination, which mirrored the natural blue and white of the sky, and was instantly sympathetic to the surroundings.[8] In typically dark Victorian interiors, the brilliant contrast of glazed blue-and-white china had a brightening effect, becoming an essential element of the 'house beautiful', and providing an opportunity for its owners to emulate the lives of artists and the wealthy.

Collecting blue-and-white china rapidly became a fashionable endeavour, not only amongst artists but also within a growing middle class, which had gained wealth through industrial enterprise. With money enabling access to art, members of this expanding commercial elite, such as Leyland, purchased and commissioned paintings by notable Aesthetic artists, and felt invigorated to collect blue-and-white china to affirm their artistic, cultivated tastes. Sir Henry Thompson, a leading surgeon and painter, amassed a significant collection of blue and white that he eventually sold through Murray Marks, the acknowledged authority on Chinese porcelain who had been responsible for supplying and shaping the collections of Thompson and Leyland amongst many others.[9] The catalogue of Thompson's collection, published in 1878 as *A Catalogue of Blue and White Nankin Porcelain,* included attractive illustrations by Whistler and stoked the fire for new collectors. One of these was James Orrock, a watercolour artist whose devotion to collecting landed him the titles 'Admiral of the Blue' and the 'Emperor of China'.[10] A selection of Orrock's fine Kangxi period wares were purchased by the South Kensington Museum in 1886–7 (figs 29, 30). Marks also assisted William Cleverly Alexander, a successful banker and patron of Whistler's, who participated in the 'Blue and White' Exhibition staged by the Burlington Fine Arts Club in 1895. The accompanying catalogue recounts that the taste for blue and white had 'risen almost to a mania'.[11] This astronomical rise in popularity in the final decades of the nineteenth century was matched in cost, as famously illustrated by Louis Huth's 'Hawthorn' jar, which sold for a record price of almost £6,000 in 1905,

27
'Double-gourd' vase,
1800–75
Japan
Patinated bronze,
H 40.6 cm

V&A: 148-1876

28
'Double-gourd' vase, c.1880
Designed by Christopher
Dresser (1834–1904) for
the Linthorpe Pottery,
Middlesbrough
Glazed earthenware,
H 37.5 cm

V&A: C.237-2014

29
**Ginger jar from the
collection of James Orrock
(1829–1913)**
China, Qing dynasty,
Kangxi period, 1683–1710
Porcelain painted in
underglaze blue,
H 25.5 cm

V&A: 274&A-1886

a far cry from the £25 Huth paid for it in the early 1860s.[12] The exorbitant values attached to these collectable commodities indicate the contentious and extraordinary relationship that existed between Art and Money, Whistler's two hostile sparring peacocks, and foreshadow a decadent society on the brink of collapse, as visualized so powerfully in *Filthy Lucre*.

Museums played a crucial, symbiotic role in encouraging collectors of 'oriental' art. Indeed, Henry Cole, the first Director of the South Kensington Museum and a passionate art educator, believed it was 'from the East that the most impressive lesson was to be learnt'.[13] With the aim of inspiring contemporary British designers and informing public taste with the finest examples of decorative art, the South Kensington Museum published a catalogue of its Chinese art collection in 1872, which included 200 examples of Chinese porcelain.[14] Acquisitions were steadily made and displayed to the public in the Oriental Courts, including some early gifts from Queen Victoria and a large collection of Japanese porcelain and pottery, exhibited at the 1876 Philadelphia

30
**Jar and lid from the
collection of James Orrock**
China, Qing dynasty,
Kangxi period, 1700–10
Porcelain with powder-blue
glaze and painted in
underglaze blue,
H 45.7 cm

V&A: 67&A-1887

International Exhibition and purchased by the Museum. Chinese ceramics were bought in the 1880s with the assistance of Dr Stephen Bushell, an art enthusiast and physician at the British Legation in Peking, who acted as an agent for the Museum. In 1876, the Bethnal Green Museum exhibited a collection of 'oriental' ceramics assembled by Augustus Wollaston Franks, Keeper of the Department of British and Medieval Antiquities at the British Museum. His was an example of a more systematic collection, which endeavoured to categorize all types of porcelains in a meaningful way, with maiden attempts to distinguish the products of China and Japan.[15] Franks's collection was later gifted to the British Museum, and indeed the passion for private collecting often greatly benefited public institutions. One of the most significant acquisitions for the South Kensington Museum in this regard was the bequest in 1910 of George Salting, another wealthy client of Murray Marks, who left the Museum an enormous collection including over 1,000 Qing dynasty porcelains. Like Leyland, Whistler regularly sold off and altered his collection throughout

his lifetime; yet by his death, Whistler's collection of blue and white still numbered over 300 objects, now in the Hunterian Museum, Glasgow (fig.31). The sheer number of pieces amassed by these individuals indicates a consumer and collector culture like nothing that had gone before.

Unsurprisingly, not everyone with social aspirations had the means to engage in 'Chinamania' on this scale, yet rising wages and increased availability of goods enabled many of the middle and lower classes to participate to some extent in the craze for blue and white. For those without a natural eye for beauty, guidance came in the form of a variety of journals and household decoration manuals, which gave clear instruction in the art of furnishing and decorating one's home in a sophisticated Aesthetic style. Following on from Charles Eastlake's *Hints on Household Taste* (1868) and various manuals by Mrs Haweis, which could only be afforded by prosperous households, came the 'Art at Home' series in 1876–8 (referenced earlier), cheaply-priced deliberately to reach a wide audience.[16] As an essential marker of good taste, naturally these guides promoted the use of blue-and-white porcelain as a vital decorative feature in the home, endorsing its superior status with such comments as, 'would not one rather fracture a limb than break a friend's old Persian or Chelsea, or Nankin?'[17]

The introduction of art furniture provided ceramics with a prominent stage in the home, with sideboards and cabinets designed specifically for the elegant display of such ornaments. The deliberate intention that ceramics should be used to complement furniture is evident in the work of architect and designer E.W. Godwin, a close friend of Whistler's, who regularly included sketches of ceramics in his designs for 'Anglo-Japanese' ebonized wood furniture and interior schemes (fig.32). The flat, clean lines of Aesthetic furniture were thought to promote hygiene, and thus ceramics became the ideal accompaniment, with smooth, durable surfaces that could easily be wiped clean whilst remaining immune to environmental changes in light or temperature. In the only three-dimensional ceramics by Godwin that survive, a pair of vases marry furniture and ceramics further in a tongue-in-cheek comment on the popularity and plagiarization of his designs. Incised in a Japanese

31
James Abbott McNeill Whistler
The Artist in His Studio, 1865–6
Oil on paper mounted on panel, 62.9 x 46.4 cm

The Art Institute of Chicago, Friends of American Art Collection: 1912.141

Whistler depicts himself painting in the studio, with his collection of blue-and-white porcelain in the background.

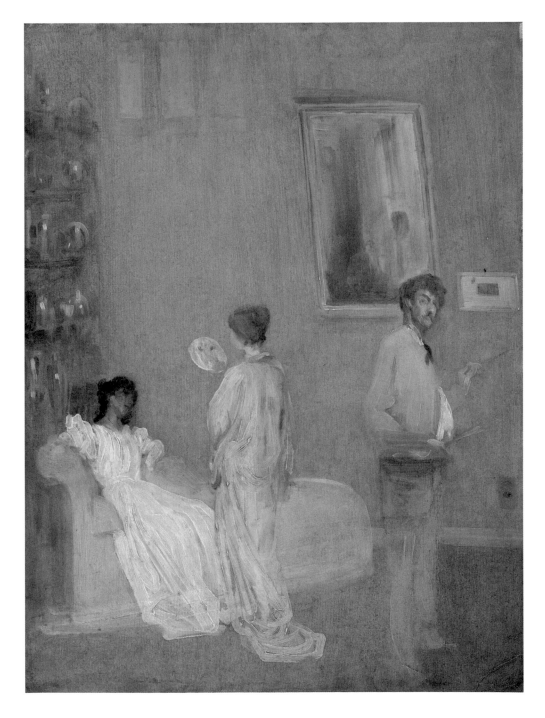

style, the decoration includes a stork overlooking a classic Godwin-designed table, alongside the telling word 'kawphyrite' (copyright) (fig.33). Although seemingly light-hearted, the lack of due credit, recognition and payment was, and still is, a troubling issue for artists and designers, an issue manifested so distinctly in Whistler's work on the Peacock Room.

Although ceramics were in many ways integral to the artistic home, the household guides occasionally offered a surprisingly sympathetic awareness of financial restraints, with the suggestion that for those whose minds have not been 'spoiled by the luxury of wealth', there is keen pleasure to be had in just 'one' affordable but beautiful new treasure, such as 'a piece of Nankin blue'.[18] Access and affordability were increasing, with antique blue and white becoming more available not only at high-end shops, such as Liberty & Co., but also at cheaper traders. No matter the size of the collection – be it three or three hundred – great significance was given to the placement of these objects within the home, with harmonious arrangement as fundamental to the effect of beauty as the objects themselves. The elaborate shelving structure designed by Thomas Jeckyll for the Peacock Room is an extreme example, intended to show off Leyland's large collection in spectacular fashion with clearly delineated horizontal and vertical sections for each piece. Successful display of objects in the home would confer social status, artistic appreciation and cultural relevance, values disrupted in *Filthy Lucre* by the chaotic disorder of the ceramics and their surroundings, presenting a monstrous alternative to the Aesthetic ideals of balance, order and carefully considered artistic display. The fanatic pursuit of beauty can both enrich and damage, as seen in the relationship between Whistler and Leyland, and despite proselytizing about the importance of good home furnishing and decoration, the manuals do advise that 'people of small income' should not prevent themselves from fulfilling their familial duties, making the concession that there perhaps might be more important priorities than the latest 'aesthetic curtains' or 'blue china'. In a final stroke of reason, we are reminded that in the quest to preach the power of beauty, one must not forget that the 'best decoration for a dining room is a well-cooked dinner'.[19]

32
Edward William Godwin
(1833–1886)
**Design for a cabinet in the
Japanese style, 1874 (detail)**
Pencil, pen and ink and
watercolour

V&A: E.478-1963

33
Pair of vases, c.1877
Designed by Edward William
Godwin
Earthenware with incised slip
decoration, H 20.7 cm

V&A: C.1-2008; C.2-2008

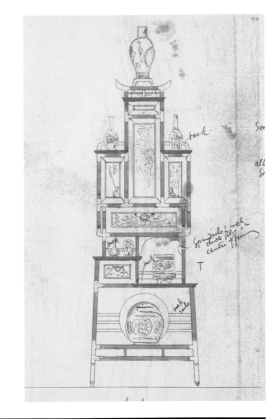

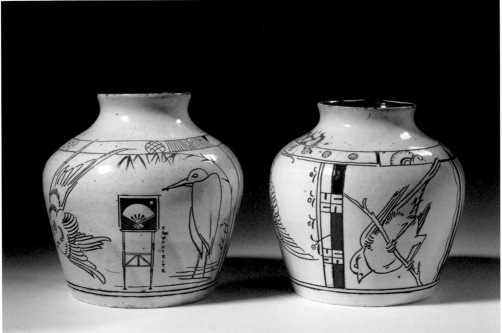

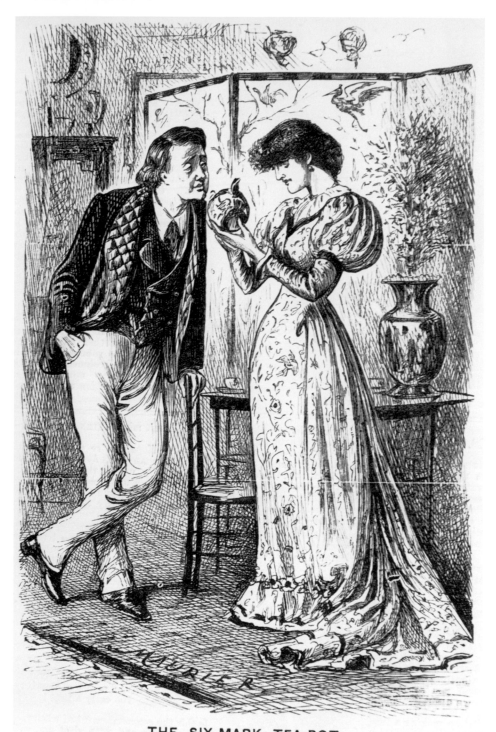

THE SIX-MARK TEA-POT.

Æsthetic Bridegroom. "IT IS QUITE CONSUMMATE, IS IT NOT?"
Intense Bride. "IT IS, INDEED! OH, ALGERNON, LET US LIVE UP TO IT!"

34
George du Maurier
(1834–1896)
The Six-Mark Tea-Pot
Punch, 30 November 1880

V&A: NAL

35
George du Maurier
Pet and Hobby (Showing that Chinamaniacs have their Affections like other People)
Pen-and-ink drawing for
Punch, 26 August 1876

V&A: E.399-1948

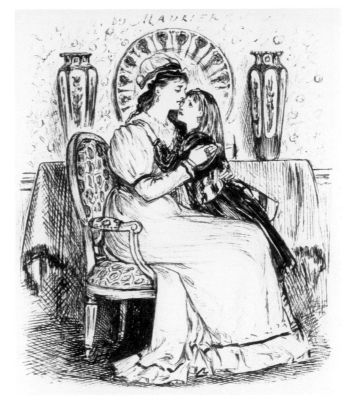

The Aesthetic notion that beauty was to be found and admired in certain objects was picked up by satirists at the time, who ridiculed Aesthetes for their emotionally intense relationships with inert material goods. Ceramics played a crucial role in this satire, with the passion for blue-and-white china and teapots being common targets. Formerly residing in the domestic sphere of women, to many the new interest of men in these objects represented a dangerous blurring of traditional gender roles and weakening of masculine identity. The cartoonist George du Maurier's *The Six-Mark Tea-Pot* shows an Aesthetic bride and groom intently admiring a new teapot, referencing the title of Whistler's earlier painting (see fig.23) whilst mocking Oscar Wilde's admission that every day he found it 'harder and harder to live up to' his blue china (fig.34). Painting a highly pretentious picture of Aestheticism, du Maurier played on the fears that an Aesthetic outlook was detrimental to good morals and one's familial responsibilities. *Pet and Hobby (Showing that*

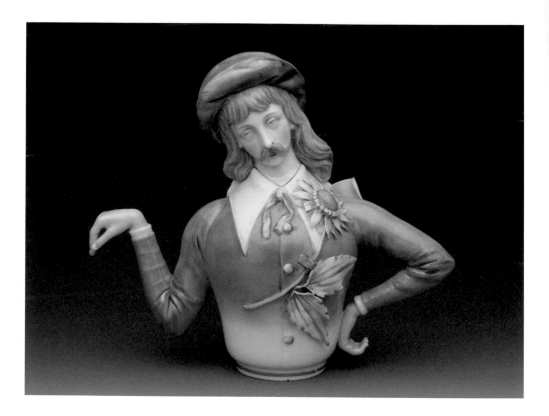

36

Aesthetic Teapot (front and back), 1882

Modelled by James Hadley for the Royal Worcester Porcelain Factory

Glazed parian, H 15 cm

Museum of Royal Worcester: 2561

Chinamaniacs have their Affections like other People) satirizes the Aesthete's perceived love for blue and white over all else, and shows a daughter hesitating before confirming that she loves her mother even 'better than Blue China', an exclamation which leaves the mother 'much moved' (fig.35). Indeed, du Maurier's cartoons for *Punch* from 1873 to 1881 have become so associated with the Movement that they have since constituted many people's principal understanding of Aesthetic beliefs and behaviour.

The ultimate caricature of the Aesthete is nowhere better portrayed than in Royal Worcester's 'Aesthetic Teapot', modelled by James Hadley in 1882 (fig.36). An anti-Aesthetic joke incorporating both Wilde's famous quip about his blue-and-white china and Darwin's theory of evolution, the teapot bears the inscription 'Fearful consequences through the laws of Natural

Selection and Evolution of living up to one's Teapot'. A male Aesthete and his female counterpart have evolved into their most prized possession, the limp-wristed spout and their melancholic expressions a reflection of the dissatisfaction and futility to be found within the Aesthetic psyche. Adorning the figures with typical Aesthetic motifs of the sunflower and the lily, Hadley parodies the laboured use of these and other symbols of 'beauty' on much decorative design throughout the period. W.S. Coleman, Director of Minton's Art Pottery branch in London, specialized in painting plaques and chargers in a highly Aestheticized style, typically depicting young boys, or girls on the cusp of womanhood, amongst an array of plants, flowers and decorative accessories, indulging in a life of sensation (fig.37). Whistler's scheme for Leyland's dining room was a shrine to another Aesthetic icon: the peacock, whose

37
Plate, c.1871
Designed and painted by
William Stephen Coleman
(1829–1904) for Minton Art
Pottery, London
Painted earthenware,
W 24.5 cm

V&A: C.74-2018

38
Dish, c.1888–98
Designed by William De
Morgan (1839–1917)
Painted earthenware,
W 41.5 cm

V&A: C.261-1915

shimmering feathers were often displayed inside blue-and-white vases and were thought to be 'so entirely decorative that they cannot fail to be appreciated if properly placed'.[20] Peacocks and their feathers were frequently used as a decorative device to appeal to Aesthetic tastes, as seen in the work of art potter and designer William De Morgan and the portrait plaques of painter Charlotte Spiers (figs 38, 41). In an early adoption of these motifs, Edward J. Poynter's designs for the Grill Room at the South Kensington Museum include tile panels featuring peacocks, sunflowers, and women in elegant poses, as well as a repeating peacock design in the plaster frieze (fig.40). Depictions of sunflowers, lilies, peacocks, fans and blue-and-white china were used throughout the period across a variety of media, becoming the 'beautiful' things commonly used to identify the Aesthetic Movement and its followers (fig.39).

39
Albert Ludovici (1852–1932)
Satirical greeting cards, 1881
Colour lithograph on card,
12.5 x 8.5 cm

V&A: E.2413 to 2416-1953

40
Edward John Poynter
(1836–1919)
**'Design for a Panel to be
done in Majolica Tiles', 1869**
Pencil and watercolour,
66.4 x 39.1 cm

V&A: 7917A

41
Plate, 1882
Painted by Charlotte Spiers
(1844–1914)
Painted earthenware,
W 31 cm

V&A: C.88-2018

Amongst the many complex narratives explored in both *Filthy Lucre* and the Peacock Room is the rich and varied story of ceramic production, consumption and display in mid-to-late nineteenth-century Britain and beyond. Once the Peacock Room had been purchased by Freer and shipped to the United States in 1904, the shelves were filled with over 250 ceramics from his collection, including pieces from across Asia that encompassed the Middle East and Korea – a wider remit than Leyland's (fig.42). The result was a display of increased variety and colour, and no longer limited to porcelain. In fact it is Freer's collection of earthenwares, with their monochromatic bright glazes, which seems to have influenced Waterston's ceramics most when creating *Filthy Lucre*. Here, the serene and uniformly blue-and-white porcelains so admired in the nineteenth century are replaced with a gaudy explosion of colour, surface texture and, crucially, destruction. Standing in shocking contrast to the V&A's Ceramics Galleries, where we work to protect and preserve the world's finest collection of ceramics for future generations, *Filthy Lucre* enables an immersive and unsettling experience with this historic and dynamic art form.

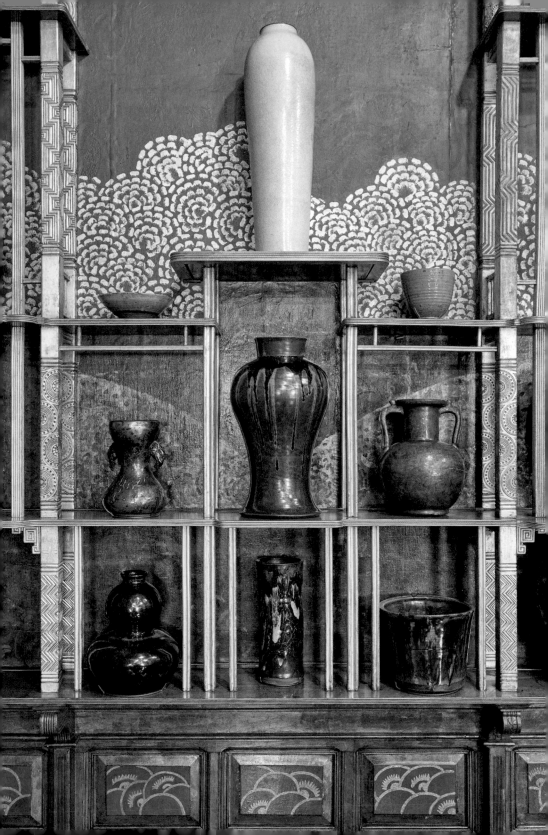

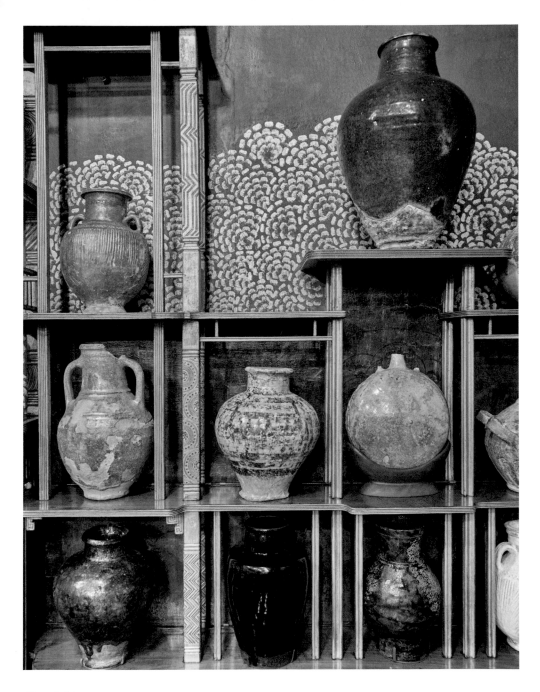

42 and 43

The Peacock Room, 1876–7, installed at the Freer Gallery of Art, with ceramics from the collection of Charles Lang Freer

Freer Gallery of Art, Smithsonian Institution, Washington D.C.: Gift of Charles Lang Freer, F1904.61

Notes

Pictor-pugnax

1 Savage 1990, p.46

2 Anderson and Koval 1995, p.186

3 Tsui 2017 [access date 2 October 2019]

4 Lee Glazer, 'A Story of the Beautiful: Whistler's Peacock Room' in Cross 2014, p.79

5 Pennell and Pennell 1908, p.204

6 Barringer 2016 [access date 2 October 2019]

Chinamania

1 David Howard, *A Tale of Three Cities: Canton, Shanghai & Hong Kong. Three Centuries of Sino-British Trade in the Decorative Arts*, exh. cat., Sotheby's (London, 1997), cited in Davids and Jellinek 2011, p.8

2 Tomoko Sato and Toshio Watanabe (eds), *Japan and Britain: An Aesthetic Dialogue 1850–1930* (London, 1991), p.19

3 Christine Guth, in Calloway and Federle Orr 2011, p.110

4 'A Plea for Aestheticism', *Burlington: A High Class Monthly Magazine* (2 July 1882), cited by Walter Hamilton, *The Aesthetic Movement in England* (London, 1882), p.126

5 Martha Jane Loftie, *The Dining-Room* in the series 'Art at Home' (London, 1878), p.109

6 Ibid, pp.15–16

7 Lucy Orrinsmith, *The Drawing-Room: Its Decorations and Furniture* (London, 1878), p.134

8 Alexander T. Hollingsworth, *Blue and White China*, (London, 1891), p.25

9 Williamson 1909

10 Merrill 1998, p.176

11 Burlington Fine Arts Club, *Catalogue of Blue and White Oriental Porcelain Exhibited in 1895* (London, 1895), p.vi

12 Merrill 1998, p.170

13 Henry Cole, *Lectures on the Result of the Great Exhibition* (London, 1852), p.112

14 Science and Art Department of the Committee of Council on Education, South Kensington Museum, *Catalogue of Chinese Objects in the South Kensington Museum. With an introduction and notes by C. Alabaster* (London, 1872)

15 Pierson 2007, p.73

16 Gere and Hoskins 2000, pp.79–80

17 Orrinsmith (cited note 7), p.134

18 Ibid, p.133

19 Loftie (cited note 5), pp.19–21

20 Orrinsmith (cited note 7), p.121

Further Reading

Anne Anderson, '"Fearful Consequences ... of Living up to One's Teapot": Men, Women, and "Cultchah" in the English Aesthetic Movement c.1870–1900', *Victorian Literature and Culture,* vol.37, Issue 1 (March 2009), pp.219–54

Ronald Anderson and Anne Koval, *James McNeill Whistler: Beyond the Myth* (New York, 1995), p.186

Tim Barringer, 'Art, Music, and the Emotions in the Aesthetic Movement', *19: Interdisciplinary Studies in the Long Nineteenth Century*, 2016 (23), http://doi.org/10.16995/ntn.784

Stephen Calloway and Lynn Federle Orr (eds), *The Cult of Beauty: The Victorian Avant-Garde 1860–1900*, exh. cat., V&A (London, 2011)

Deborah Cohen, *Household Gods: The British and their Possessions* (New Haven CT, 2006)

Susan Cross (ed.), *Darren Waterston, Filthy Lucre* (New York, 2014)

Roy Davids and Dominic Jellinek, *Provenance: Collectors, Dealers and Scholars: Chinese Ceramics in Britain and America* (Oxon, 2011)

Charlotte Gere and Lesley Hoskins, *The House Beautiful: Oscar Wilde and the Aesthetic Interior* (London, 2000)

Lionel Lambourne, *The Aesthetic Movement* (London, 1996)

Linda Merrill, *The Peacock Room: A Cultural Biography* (New Haven CT, 1998)

Elizabeth Robins Pennell and Joseph Pennell, *The Life of James McNeill Whistler*, vol.1 (London, 1908), p.204

Stacey Pierson, *Collectors, Collections and Museums: The Field of Chinese Ceramics in Britain, 1560-1960* (Bern, 2007)

Kirk Savage, 'A Forcible Piece of Weird Decoration: Whistler and *The Gold Scab*', *Smithsonian Studies in American Art*, vol.4, no.2 (Spring 1990), p.46

Susan Weber Soros and Catherine Arbuthnott (eds), *Thomas Jeckyll, Architect and Designer*, exh. cat., Bard Graduate Center (New York, 2003), https://www.bgc.bard.edu/gallery/exhibitions/44/thomas-jeckyll

Aileen Tsui, '"A Harmony in Eggs and Milk": Gustatory Synesthesia in the Reception of Whistler's Art', *Panorama: Journal of the Association of Historians of American Art*, vol.3, no.2 (Fall 2017), https://doi.org/10.24926/24716839.1607

James Abbott McNeill Whistler (1890), *The Gentle Art of Making Enemies*, ed. Mark Diederichsen (Los Angeles, 2015)

G.C. Williamson, *Murray Marks and His Friends: A Tribute of Regard* (London, 1909)

Picture Credits

Darren Waterston artworks:

Filthy Lucre © Darren Waterston, courtesy of MASS MoCA, the artist and DC Moore Gallery, New York: cover, inside cover, title page, 4, 16–27, 33, 40–1, 48, 52–3, 62, 63

Canto: Courtesy of DC Moore Gallery, New York: pp.14–15

Pavo 21: Private collection; courtesy of Weingarten Art Group and Inman Gallery, Houston: p.13

Pavo 33: Collection of Brad Nagar and Reid Sutton; courtesy of Inman Gallery, Houston: p.12

Serpent and Master: Courtesy of Greg Kucera Gallery, Seattle: pp.10–11

Darren Waterston Studio and DC Moore Gallery, New York: pp.6, 8–9

Other artworks:

The Art Institute of Chicago, IL, USA / Friends of American Art Collection / Bridgeman Images: p.77

Courtesy of the Fine Arts Museums of San Francisco: p.28

Freer Gallery of Art, Smithsonian Institution, Washington, D.C.: Gift of Charles Lang Freer: pp.31, 42, 44–5, 46–7, 50–1, 90, 91

The Hunterian, University of Glasgow: pp.35 (above), 54–5, 56–7

Reproduced by kind permission of the Museum of Royal Worcester © Dyson Perrins Museum Trust: pp.82, 83

Philadelphia Museum of Art, Pennsylvania, PA, USA / John G. Johnson Collection, 1917 / Bridgeman Images: p.64

Private Collection / Photo © Christie's Images / Bridgeman Images: p.60

University of Glasgow Library, Archives & Special Collections: p.35 (below)

The Victoria and Albert Museum: pp.36 (Given by Leonard Raven-Hill), 37 (Given by Messrs Barnards Ltd), 38 (Gabrielle Enthoven Collection), 58 (Given by Michael Harari, in memory of his father, Ralph A. Harari), 59, 66–7 (Salting Bequest), 69, 71 (The 2nd Lieutenant Francis Bedford Marsh 1914–1918 War Memorial Gift), 72 (left), 72 (right; Purchased with the support of the Decorative Arts Society and its Members), 74, 75, 79 (above; Given by Mr Edward Godwin, son of the artist), 79 (below; Purchased with Art Fund support), 80, 81 (Bequeathed by H.H. Harrod), 84 (Gift of Ian and Rita Smythe), 85 (Given by Mr Archibald Anderson), 86–7 (Bequeathed by Guy Tristram Little), 88, 89 (Gift of Ian and Rita Smythe)

Photo credits:

Colleen Dugan: pp.44–5, 46–7, 90–1

Amber Gray: cover, inside cover, pp.4, 16–27, 33, 40–1, 48, 52–3, 63

Neil Greentree: pp.50–1

Olympia Shannon: title page, p.62

Acknowledgements

Filthy Lucre emerged from the minds, hearts and hands of many; from the patrons to the curators, the realization of this project is due to the efforts and generosity of remarkable interlockers.

I am most grateful to the exuberant James Robinson from the V&A and Steph Scholten from The Hunterian for being the catalysts in bringing *Filthy Lucre* to the UK and to Julian Raby who brought us all together. Thank you to Daniel Slater and the fabulous V&A staff and a special plume of peacock feathers to Manuela Buttiglione, the V&A exhibitions manager.

Heartfelt thanks to the originating curators Susan Cross and Lee Glazer, who became the chief guardians and champions of *Filthy Lucre*. I am indebted to these two marvellous women.

Thank you again to the fabrication team at MASS MoCA and especially Derek Parker, who played an inestimable role in every aspect of design, fabrication and installation.

A big shout out to BETTY who created the beautifully dissonant soundscape, composed and performed by Amy Ziff, Elizabeth Ziff and Alyson Palmer and produced by Michael Thorne.

For images in this publication, thanks are due to picture researcher Lucy Macmillan; Stephanie Anderson, Anderson Hopkins; Jennifer Berry, Freer Gallery of Art and Arthur M. Sackler Gallery; Sophie Heath, Museum of Royal Worcester; Alicia Hughes and Graham Nisbet, The Hunterian; Niki Russell, University of Glasgow Library, Archives & Special Collections. Particular thanks to photographer Amber Gray and her partner Julian Bernstein for capturing the glimmer in the shadows, documenting the project with such moody interpretation.

Thank you to Thad Meyerriecks and Bourlet Art Logistics for keeping *Filthy Lucre* safely stored and cared for and to my gallerists Bridget Moore, Greg Kucera and Kerry Inman for unwavering support and guidance.

Lastly, I would like to thank Nicole Miller, my studio manager extraordinaire, who truly makes everything possible.

Darren Waterston